ST JOHN'S
CO-CATHEDRAL
Valletta

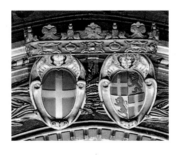

CYNTHIA DE GIORGIO

PHOTOGRAPHY
DANIEL CILIA

HERITAGE BOOKS
IN ASSOCIATION WITH
THE ST JOHN'S CO-CATHEDRAL FOUNDATION

2007

HOW TO GET TO THE ST JOHN'S CO-CATHEDRAL

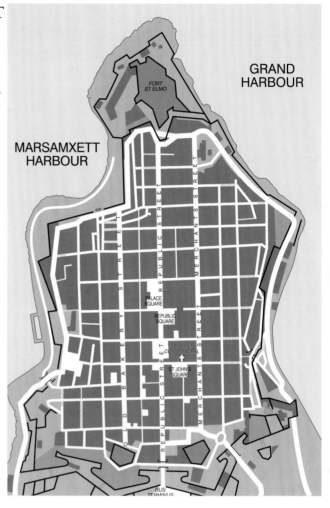

St John's Co-Cathedral is situated in the heart of Valletta.

It is easily reached by foot and the visitors' entrance is found on Republic Street as you enter Valletta through the Main Gate. The entrance lies just as you cross St John's Street, opposite the Law Courts, behind the Great Siege Monument.

Malta Insight Heritage Guides Series No: 17
General Editor: Louis J. Scerri

Published by Heritage Books, a subsidiary of
Midsea Books Ltd, Carmelites Street,
Sta Venera SVR 1724, Malta
sales@midseabooks.com
www.midseabooks.com

*Insight Heritage Guides is a series of books intended
to give an insight into aspects and sites of Malta's
rich heritage, culture, and traditions.*

Produced by Mizzi Design & Graphic Services

First published 2007
This edition 2010

ISBN: 978-99932-7-171-0

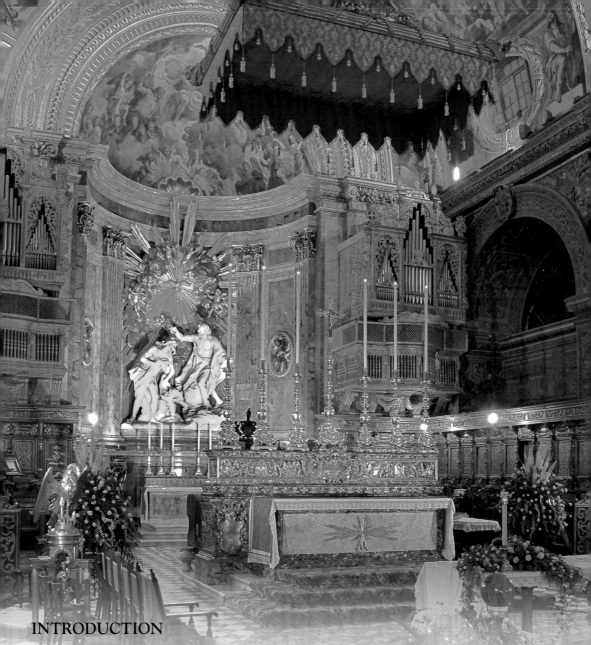

INTRODUCTION

St John's Co-Cathedral is a gem of Baroque art and architecture. Its rich history and artistic heritage is due to the fact that, for over 200 years, it was the conventual church of the Order of St John of Jerusalem. The history of the church is directly tied to the history of the Order in Malta. Over the years, the grand masters, dignitaries, and knights donated gifts of high artistic value and made enormous contributions to enrich it with the best works of art by the leading artists available to them. The knights themselves referred to the church as *'la nostra chiesa maggiore della Sacra Religione Gerosolmitana'*. The upkeep of St John's occupied the topmost position in the annual budget of the Order, thus maintaining it in continuous splendour.

The church was administered by a chapter of *cappellani maggiori* who were ordained members of the Order, headed by a prior, who ranked third in dignity after the grand master and the bishop of Malta. This post was considered a most prestigious one and the prior was allowed to wear a bishop's mitre and carry a crozier.

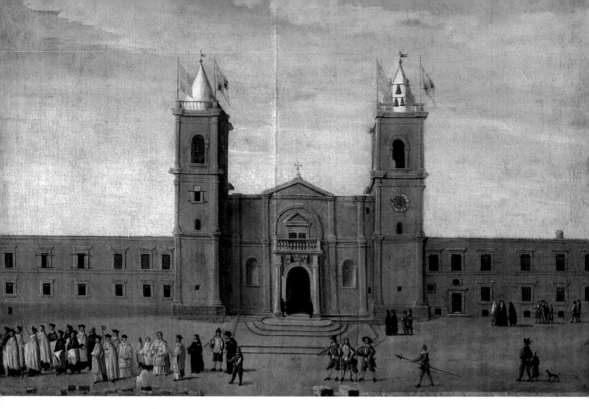

THE ORDER, THE SIEGE, AND VALLETTA

The Order of St John was founded in the eleventh century in Jerusalem as a religious brotherhood to provide shelter for pilgrims to the Holy Land. The knights were noblemen from some of the most important families of Europe and they had a mission – to protect the Catholic faith and Europe from the attacks of the Ottoman Turks. After Jerusalem fell to the Ottoman Turks, the knights took on a military role. Having lost their military bases first in Jerusalem and then in Rhodes, in 1530 the Order was given Malta by Emperor Charles V of Spain under whose crown it fell. Malta soon became the stronghold of Christendom, inevitably attracting the attention of the Ottoman Turks. In 1565 the knights and Malta suffered a huge attack by the Ottomans which ended in victory for the knights. After this event, known as the Great Siege, it seems that the knights vowed to turn Malta into a fortress that befitted a military Order with a capital city worthy of so illustrious a group of noblemen.

The Great Siege had severely damaged the residence of the Order in the town of Birgu. Grand Master, Jean de Valette,the hero of the siege, realized that a new fortified city was necessary if the Order was to present a strong resistance to any future Ottoman attacks and ordered the building of a new city. The peninsula between the Grand Harbour and Marsamxett Harbour provided the ideal site for such a city. The new city, founded in 1566 just a few months after the end of the siege, was named Valletta after the grand master. Pride of place in the centre of the city was reserved for the Order's church which was dedicated to St John the Baptist, the patron saint of the Order.

THE ARCHITECTURE

The grand master commissioned the Order's architect, the Maltese Gerolamo Cassar, who was originally trained as a military engineer, to draw the plans of the conventual church. It was constructed entirely of Globigerina limestone, the most easily available local building material. Some of this stone came from on-site excavations in what was later turned into the grand masters' crypt. The construction started in 1572 and was completed in 1577, after five years of hard and continuous labour. The church was consecrated by Archbishop Ludovico Torres of Monreale who was brought over especially for this occasion.

The plain façade flanked by two large bell towers is severe and has the character of a fortress reflecting the sober mood of the Order after the Great Siege. The doorway is accompanied by a set of Doric columns supporting a balcony which was used by the grand master to address his people on important occasions. The façade is topped by a pediment which holds a copy of a high bronze relief image of Christ by Alessandro Algardi. The original, installed in 1853 after it had been removed from the church of the Saviour in the Grand Harbour, has been restored and is now exhibited in the museum.

The oratory and the sacristy were built in 1604 during the reign of Grand Master Alof de Wignacourt, whilst the annexes were built in 1748

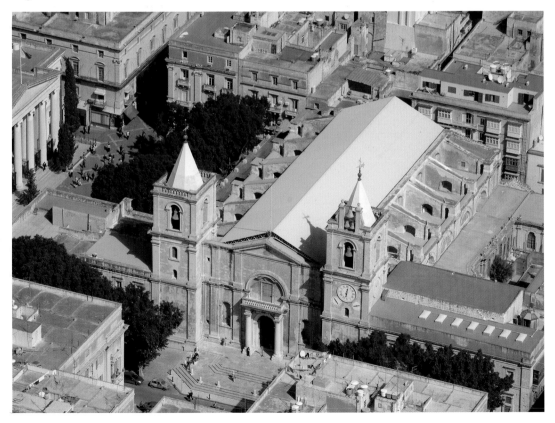

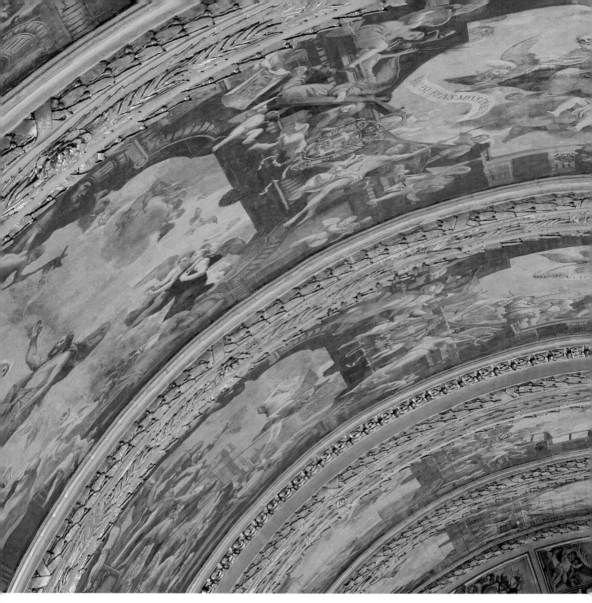

during the reign of Grand Master Manoel de Vilhena, whose armorial shield can be seen on the doorway to these side annexes.

It was Grand Master Jean l'Evesque de la Cassiere, the founder of the church, who decided to assign a chapel to each langue of the Order. This explains the image of a lion, a symbol from the grand master's coat of arms, which is displayed in the dome of each chapel. However, it was not until 1603, during the reign of Grand Master Alof de Wignacourt, that the

various langues took responsibility to embellish their chapels. The connecting passages between the chapels were made in the early 1660s.

The church has a rectangular floor plan with an apse at the east end, a wide nave, a barrel vault, and two aisles divided into side chapels. It is often said that it has been Grand Master de Valette's wish to have a church resembling the one the Order had in Rhodes. In its early days the interior was modestly decorated; it is hard to imagine the church bare of

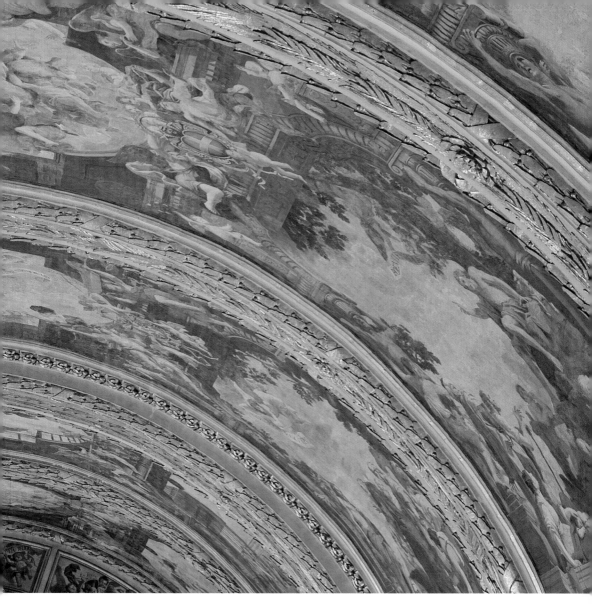

its lavish stone carving, gilding, and marble ornamentation, but this is how it remained for almost a hundred years.

During the mid-seventeenth century, referred to as the High Baroque, the arts remained an important tool in the post-Counter Reformation years. Their function, however, was not solely to instruct and convert, but also to delight the senses.

During the seventeenth century a programme to redecorate the interior of the church was started by Grand Master Raphael Cotoner. The seventeenth century had ushered in the new Baroque style and its flamboyant and demonstrative character provided ample material. The increasing popular fashion in Rome of decorating churches in the new opulent Baroque style caught the Order's attention and it was not long before the Calabrian artist Mattia Preti was commissioned to transform the interior into a celebration of Baroque art. The contrast between the sober façade and the festive mood of the interior makes St John's unique.

MATTIA PRETI AND HIS VOYAGE TO MALTA

Mattia Preti, known as *Il Calabrese*, is recognized as one of the most outstanding artists of the second half of the seventeenth century. He was born in 1613 at Taverna in Calabria. He travelled to Naples where his dynamic approach to his art soon found him commissions all over the Italian peninsula; as early as 1630 he was in Rome where he fell under the spell of Caravaggio. Between 1640 and 1646, he spent some time in Venice, where the influence of Veronese and Tintoretto became embedded in his artistic language. Having travelled extensively throughout Italy, he encountered

A detail from *Scene in a Tavern* at Palazzo Barberini in Rome, showing a self-portrait of Preti when he was in Rome

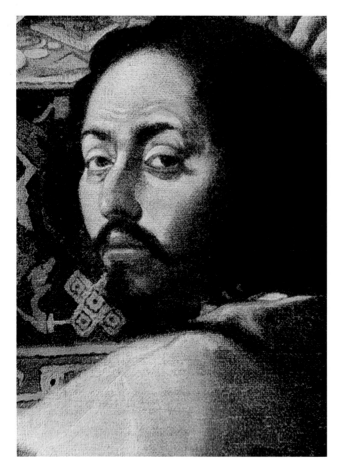

and worked alongside some of the most accomplished artists living of the times. Their influence can be detected in his highly imaginative and versatile style. From Andrea Sacchi and Nicolas Poussin, he adopted the Classical style, whilst absorbing the monumental figure groups of Giovanni Lanfranco and, occasionally, the sentimental and brooding manner of Guercino. Preti's style evolved into a stunning form of *chiaroscuro* and illusionistic effects. Perfect draughtsmanship and skilful use of colour are characteristics typical of his artistic expression. His exposure to such a variety of artistic expressions also resulted in a powerful and dramatic style and these qualities are well demonstrated in his works in Malta. Preti's paintings demonstrated, from the start, an immense vigour and dynamic power which were almost unparalleled in Italy, let alone Malta. His artistic contribution to the island was to provide an important and lasting stimulus.

In Rome Preti had received several important commissions and he made the necessary social connections for him to request admission into the Order of St John. By 1642 he was endowed with the habit of a knight of obedience.

The devastating plague that hit Naples in 1656 must have forced several individuals to flee the city but, although Preti was living and working there at the time, it seems that he had no immediate plans to leave the city. Now established as a leading artist in both Naples and Rome, he soon attracted the attention of the Order. In 1658 he was commissioned a painting by Grand Master De Redin depicting *St Francis Xavier*.

Preti eventually travelled to Malta where he was to stay, with only very brief interruptions, until his death in 1699. Initially he must have been engaged by the Italian knights to decorate their church of Santa Caterina. Soon after, he was commissioned the decoration of the vault of the conventual church. Preti seems to have had a thriving *bottega* which had a great impact on the local artistic milieu. At the same time as the immense commission to paint the vault of the church, he was also commissioned various altarpieces for the side chapels. It is during this phase that his palette best demonstrates Venetian opulence. Preti died in 1699 and was buried amongst other high-ranking knights in the conventual church of St John's, now known as the Co-Cathedral.

Mattia Preti's tombstone

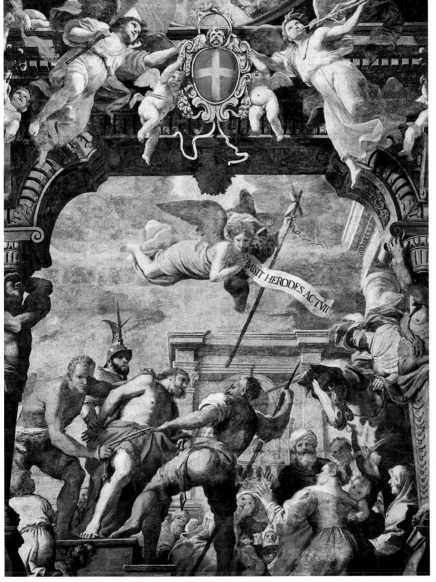

Mattia Preti, *St John the Baptist being arrested by Herod's Emissaries*, detail from bay 4

THE VAULT PAINTINGS

Starting with the barrel vault, as this type of rounded ceiling is called, Mattia Preti painted episodes from the life of St John the Baptist. By using highly illusionistic effects of skies filled with angels, he transformed and uplifted the plain and heavy vault. Normally, paintings on walls are carried out in a fresco technique which is watercolour based, but Preti used oil-based paint applied directly on to the stone. He started from the lunette above the main door where he depicted the allegory of the Order represented by Minerva, the goddess of war and wisdom, crushing Moorish slaves beneath her feet. To the left and right are the Cotoner grand masters Raphael and Nicolas who were great benefactors of the Order and this church in particular. Knights in heaps, slain in battle, and angels descending from the sky are holding palm fronds, a symbol of martyrdom.

For the next six years, Preti toiled to finish the vault. He ingeniously used the six bays to fit his narrative cycle. Each bay is subdivided into three sections. The story of St John starts from the first bay on the north side (on the right as one faces the main door) with the vision of the priest Zachary and ends with the beheading of the saint in the last bay to the right of the altar. In the apse he painted St John holding the Order's standard being presented to God the Father by Jesus Christ. Preti painted saints and martyrs, sitting on the cornice in pairs, at the side of each oval window.

Starting from:

1ˢᵗ bay: The priest Zachary's vision in the temple; Mary's visit to Elizabeth; The birth of John the Baptist.

2ⁿᵈ bay: John in the desert; Elizabeth praying, accompanied by two angels; John indicating Jesus as the Messiah.

3ʳᵈ bay: John preaching in the desert; God the Father giving His blessing; The baptism of Christ,

4ᵗʰ bay: John, imprisoned, being interrogated by priests; John handing a coin to a soldier; John the Baptist being arrested by Herod's emissaries.

5ᵗʰ bay: John warning Herod of his immorality; Salome holding John's head on a platter; John sending two disciples to Jesus.

6ᵗʰ bay: Salome dancing at Herod's banquet; A group of angels playing music; The beheading of John the Baptist.

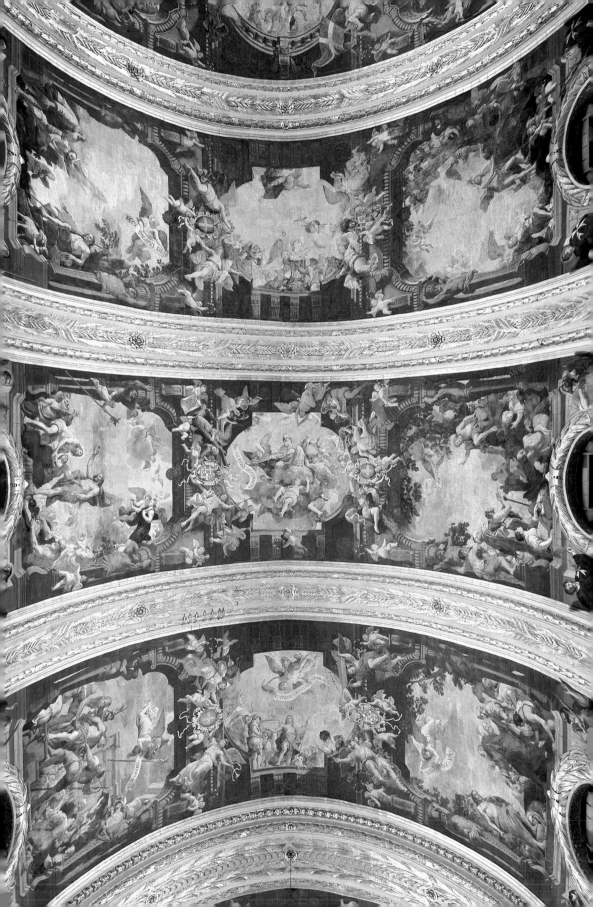

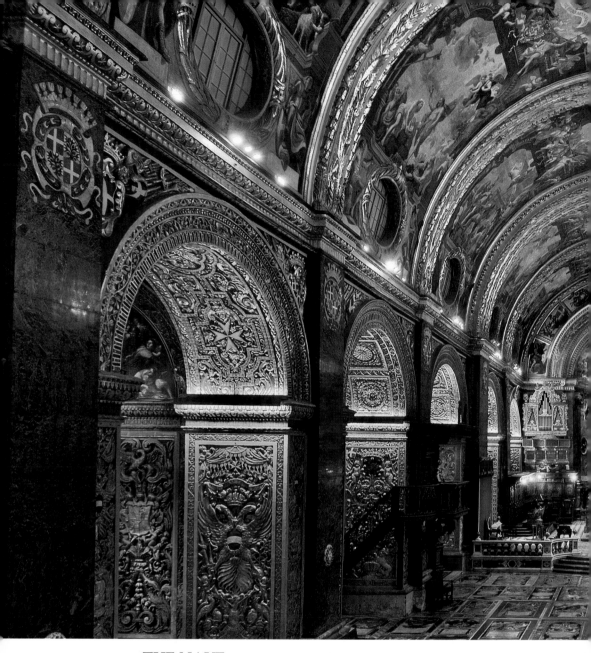

THE NAVE

The grand masters, who all took great pride in their conventual church, wanted it decorated according to the new Baroque style. During the 1650s and throughout the 1660s, a vast programme of decoration was set into motion. Significant works of art were introduced for which no expense was spared. Several coats of arms belonging to the aristocratic members of the Order can be seen indicating their owners' particular contributions.

After the vault decoration, the most significant change that transformed the church into a symphony of Baroque splendour was the carving into the soft Maltese stone of the interior walls. On designs prepared by

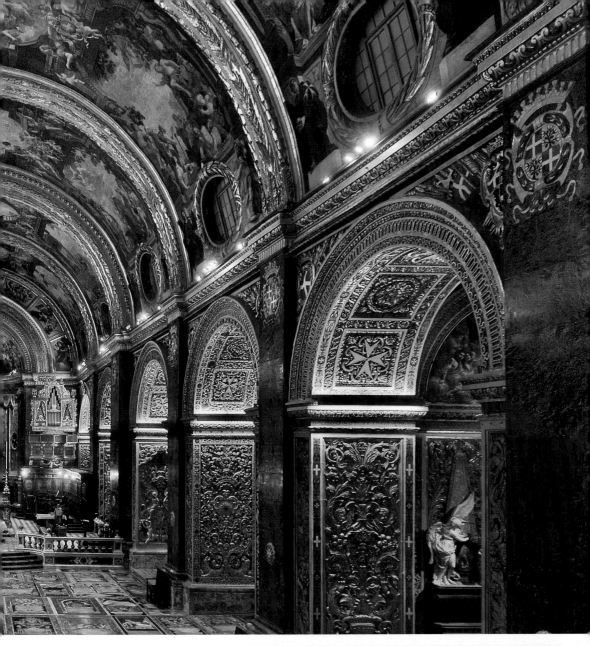

Preti, the plain walls of the nave and chapels were decorated with elaborate motifs characteristic of Baroque ornamentation, transforming the walls into a riot of richly gilded foliage, flowers, angels, and triumphal symbols of all kinds. The pilasters supporting the central nave were clad with the finest green marble at the top of which the coat of arms of Grand Master Nicholas Cotoner are displayed.

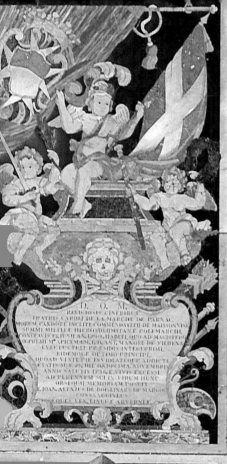

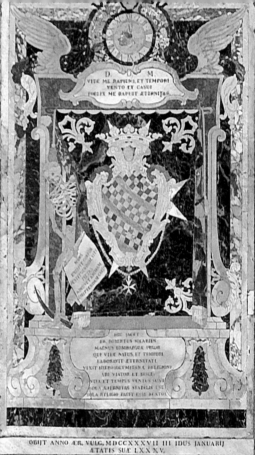

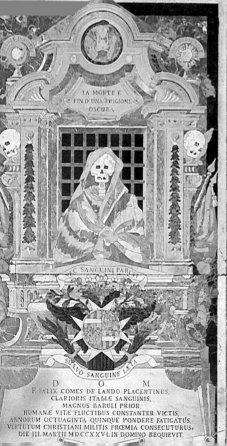

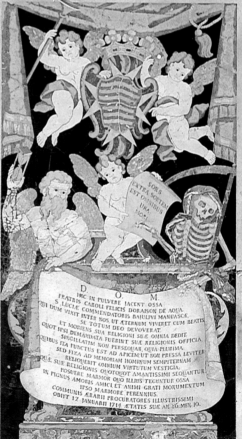

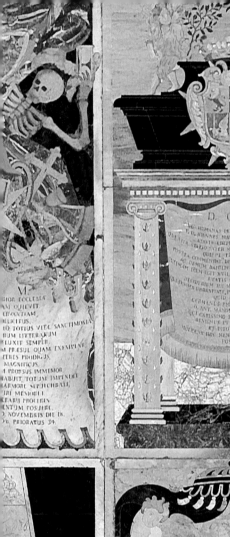

The entire floor of the church is covered with a unique collection of inlaid marble tombstones. There are approximately 400 tombstones and these commemorate some of the most illustrious knights of the Order several of whom were members of the great aristocratic Catholic families of Europe. They rank from grand priors, to admirals, to bailiffs. Crowns and coronets indicate the most noble of the knights. In date they vary from the late seventeenth century to the late years of the eighteenth century. All the tombstones were individually designed and composed of carefully selected fine coloured marble. Each tombstone is highly decorated with expressions of triumph, fame, and death. Skeletons and skulls are often included in the iconography of the tombstones. They represent the end of life on earth and the beginning of eternal life with God the Father. Amongst the most popular symbols are the angel of fame blowing a trumpet and angels holding laurel wreaths as symbol of victory. Several tombstones depict weapons and battle scenes as testimony of their chivalry. The epitaphs are in Latin and often describe the knights' virtues and achievements.

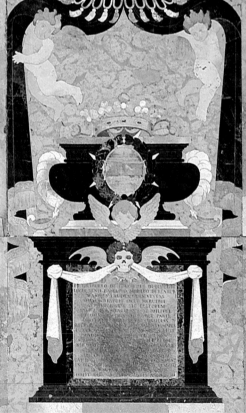
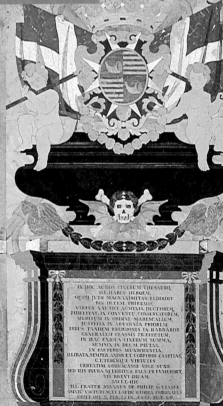

THE SANCTUARY

**On the right:
The magnificent
altar and choir
area**

The sanctuary has seen a number of changes in accordance with the Tridentine liturgical reforms, such as raising the high altar on a platform, but some alterations were made just for aesthetic purposes. Originally there was only one altar placed directly in the apse with an altarpiece depicting the baptism of Christ. This painting now hangs in the museum. The apse now holds the impressive marble figures depicting *The Baptism of Christ by John the Baptist* by Giuseppe Mazzuoli, one of the leading sculptors of the eighteenth century. The elegant style and realistic rendering of the anatomy make this group a masterpiece. The act of baptism, which is an act of conversion, had great symbolic meaning for the Order, as it represented one of its missions.

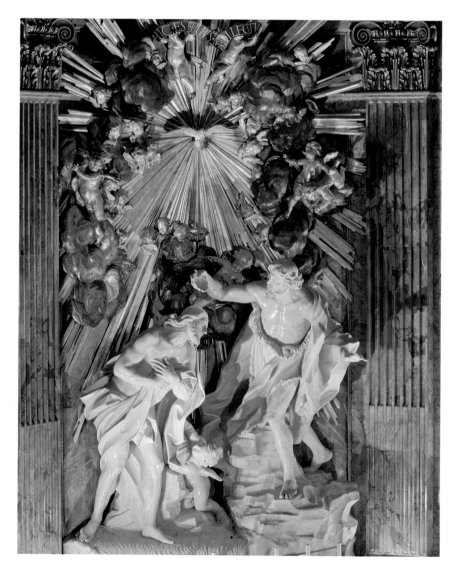

Giuseppe Mazzuoli, *The Baptism of Christ by St John*

16

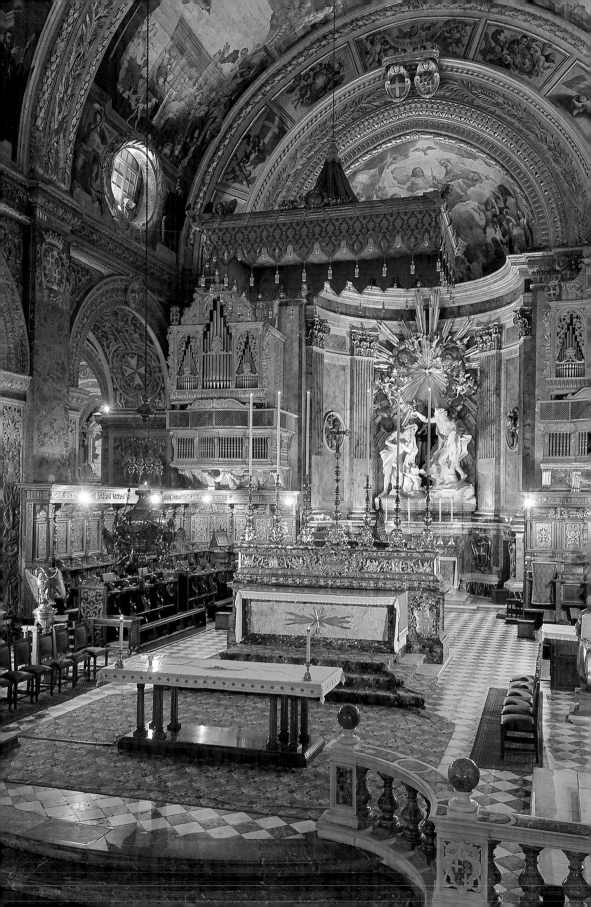

The high altar, the gift of Grand Master Carafa, is an extravagant piece composed of rare marbles. The frieze running across the altar holds the symbols of the four evangelists, the keys attributed to St Peter, and the codex and sword attributed to St Paul. The central motif depicts the Last Supper all made of gilt bronze on a lapis lazuli background.

The solid silver sanctuary lamp held by two angels is a reflection of the extravagant Baroque style and is indicative of the grandeur of the Order during the seventeenth century.

This rare treasure was donated by Bali Fra Vincenzo Rospigliosi in 1669.

The large wooden lectern dates to the reign of Grand Master Cassiere and is the work of Antonio Lazi from Piacenza. It is a magnificent late Mannerist work with atlantes figures flanking its corners. The four panels depict scenes from the life of the Baptist. This massive lectern was used to hold the graduals, a gift of Grand Master L'Isle Adam, that have some of the most exceptional illuminated manuscripts from Parisian scriptoriums and which manuscripts are exhibited in the museum.

Below: Detail from four choir panels depicting scenes from the life of St John the Baptist

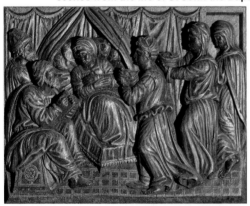

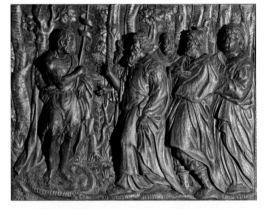

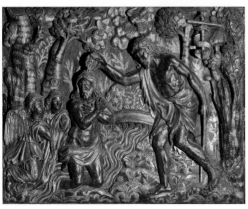

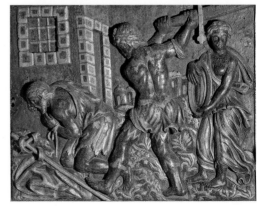

The **choir stalls**, installed in 1598, have also been attributed to Lazi. They bear the arms of the reigning Grand Master Martin Garzes (1595-1601) and the knight Fra Giorgio Gianpierei who financed them. The stalls, consisting of 52 seats arranged in two tiers, are made out of fine walnut with gilt motifs. The finely carved gilt motifs are of a refined Mannerist style and reveal the hand of a master craftsman. The small gilded bronze crucifix on the choir altar was cast in Gianlorenzo Bernini's workshop.

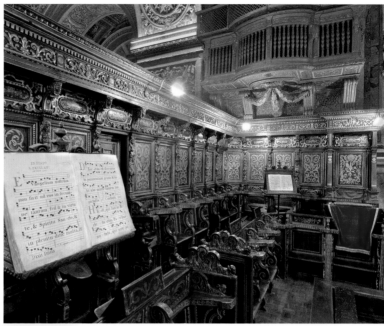

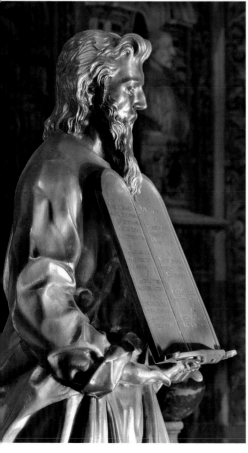

The **two bronze lecterns** were the gift of Francis, duke of Lorraine, in 1557. One consists of an eagle which is the symbolic image of St John the Evangelist whilst the other represents the figure of St Paul the Apostle holding an open codex.

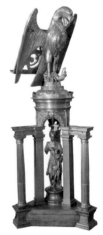

The **pulpit** is an outstanding intricately carved work of art with gilt details attributed to the Italian woodcarver Antonio Lazi. Originally placed on the other side of the church and was reached by a flight of steps from inside the pillar, it was moved to its present position during the reign of Grand Master Hugues Loubenx de Verdalle (1582-95). The staircase was added in the nineteenth century when it was moved to its present position.

THE CHAPELS

Grand Master Jean de la Cassiere had always intended to give a chapel to each langue to administer and to be used for devotion by the knights belonging to that particular national group. The formal decision was taken in 1604 during a session of the chapter general of the Order. By that date some of the chapels already had an altar with the first chapel on the south side being dedicated to Our Lady of Philermos. This chapel is now reserved for prayer and is where the Holy Sacrament is kept. There were eight langues: Castile incorporated the kingdoms of Leon and Portugal; Aragon included Valencia, Navarre, and Catalonia; the Anglo-Bavarian langue included Scotland, Wales, and Ireland; the Italian langue included Naples, Sicily, the Papal States, Tuscany, and Venice; and Germany which included Austria. The arrangement was according to the seniority of the langues. The French langues were the most senior and the three chapels of France, Auvergne, and Provence were placed closest to the High Altar.

On the south side
1. **Chapel of Our Lady of Philermos**
2. **Chapel of the Langue of Auvergne**
3. **Chapel of the Langue of Aragon**
4. **Chapel of the Langue of Castile, Leon, and Portugal**

On the north side
5. **Chapel of the Anglo-Bavarian Langue**
6. **Chapel of the Langue of Provence**
7. **Chapel of the Langue of France**
8. **Chapel of the Langue of Italy**
9. **Chapel of the Langue of Germany**

Visitors' Entrance

Entrance to the Museum

The Sacristy

The Oratory

Main Door
Visitors' Exit

The Chapel of
Our Lady of Philermos

The first chapel on the south side,
dedicated to Our Lady of Philermos,
was one of the most important
chapels for the knights for this
is where the icon of Our Lady of
Philermos was kept. This icon drew
great devotion as it was believed to
have miraculous powers and had been
in the possession of the Order since
the knights were in Jerusalem. L'Isle
Adam had brought this precious
icon from Rhodes. Before battle
the knights prayed to Our Lady of
Philermos for victory and, when they
were victorious, they presented the
key of the captured fortresses to the
Virgin. Amongst the keys which still
hang in this chapel are those of the
castles of Lepanto and Patras.

In 1798, when Napoleon expelled
the Order from Malta, Grand Master
Hompesch took this precious icon
with him together with the arm
of St John the Baptist and a relic
of the True Cross. The icon was
taken to St Petersburg but after the
Russian Revolution it was hidden
in a monastery and its whereabouts
remained unknown for several
decades. It is now exhibited in the
Fine Arts Museum of Montenegro.

The silver gates that act as an
iconostasis were installed in the
eighteenth century as a gift from the
inheritance of two prominent knights,
Bali Guglielmo de la Salle and Bali
Francesco Rovero di Guarena. The
knights often vied with one another
to give the church gifts of everlasting
beauty and prestige.

The splendid reredos was designed
by a Florentine artist working in
Messina from where most of the
marble was brought for this fine piece
of Baroque polychrome design.

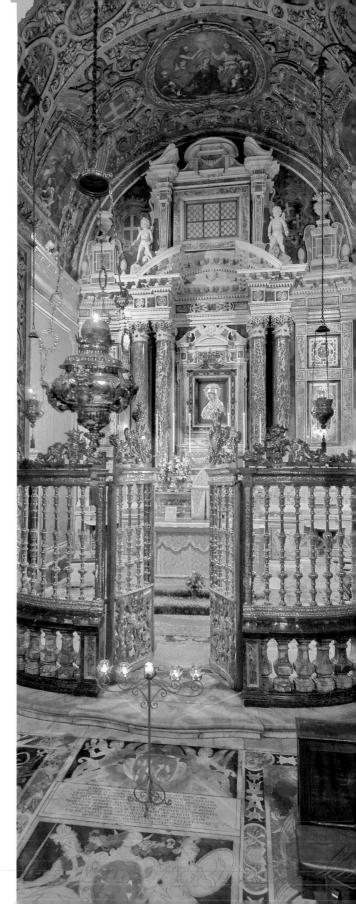

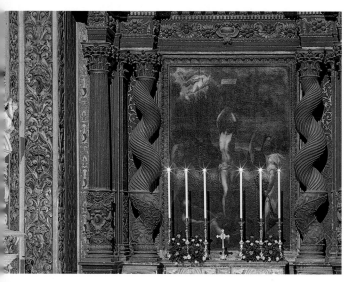

The 17th century altarpiece of the Chapel of Auvergne with its titular painting dedicated to the martyrdom of St Sebastian

On the right: The monument of Grand Master Annet de Clerment (1660)

The Chapel of the Langue of Auvergne

The chapel of Auvergne dedicated to St Sebastian, as the altarpiece testifies, is an elegant seventeenth-century work. Its sensuous appeal shows a fading Mannerist tradition yet the use of *chiaroscuro* recalls Caravaggio's influence. The seventeenth-century lunette paintings on either side of the chapel show scenes from the life of the saint. The saint's relic was brought over from Rhodes and is kept in the reliquary in the Anglo-Bavarian chapel or the Chapel of Relics, as it was once known.

The exquisite reredos that surrounds the altar is probably one of the oldest reredoses still existing in the church, many of which were replaced in the seventeenth century. This particular reredos probably dates to the mid-sixteenth century and is adorned with twisted columns.

The rich gilded coat of arms in the arch entrance and over the passageway to the next chapel is dominated by a crowned dolphin, the symbol of Auvergne. The walls of this chapel are entirely carved with rich foliage and garlands of flowers symbolizing the Order's prosperity. The magnificence of these walls owes much to the devotion of the main benefactor of this langue, Fra Jean de la Baume de Foursat. A golden fleur-de-lys on a red background can be seen in the middle of the dome. The inscription on the frieze, dated 1667, tells of his dedication to this chapel.

The only grand master buried in this chapel is Fra Annet de Clermont de Chattes Gessan. He is remembered for his military prowess during several encounters with the Turks. His white-marble monument is a typical early Baroque design; a number of such monuments be seen in this church. The central niche holds a bust of the grand master with a bird at the base. This bird comes from the coat of arms of Fra Jean Jacques de Verdelin, who was the executor of the grand master's will and who contributed to the cost of the memorial. At the very top of the monument, two cherubs help to support his coat of arms. The family coronet, with the papal tiara inserted in it, signifies a rare high-ranking privilege from the pope as recognition of loyalty to the Christian faith.

Worthy of note is the tombstone in the centre of the chapel. It commemorates a legendary hero of the Great Siege, Don Melchior de Robles, who strangely enough was not a member of the Order of St John but of the Order of the Sword. His epitaph says that he fought like a lion and died heroically for the cause of the Order and the defence of Christianity. He is still remembered every year on 8 September, when the Great Siege and all those who had fallen during the fighting are commemorated.

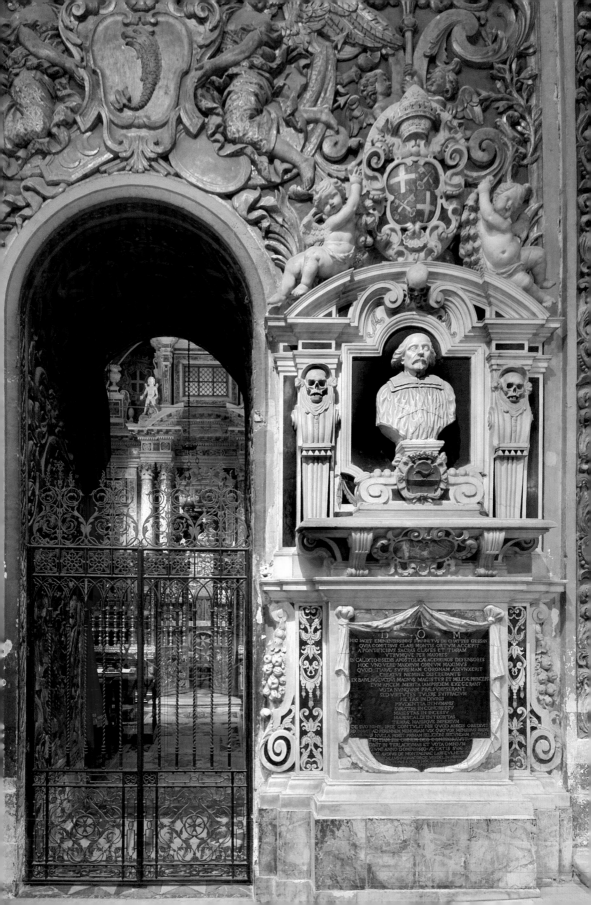

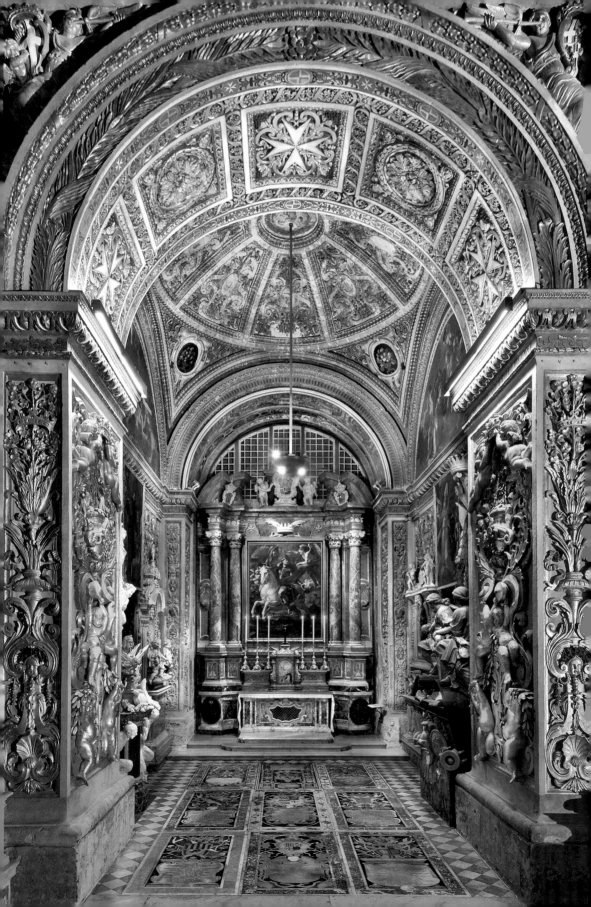

The Chapel of the Langue of Aragon

This chapel, one of the most magnificent and richly embellished in the church, is dedicated to St George, the patron saint of the Aragonese knights. The langue of Aragon consisted of the priories of Catalonia and of Navarre. The altar and its surrounds were redesigned during the reign of Grand Master Ramon Despuig (1736-41) whose effigy is represented at the base of the altar columns. The altarpiece, commissioned by Grand Master Martin de Redin in 1659, is not only one of Mattia Preti's first works in this church but also one of the most outstanding. It depicts St George on a white stallion after having killed the dragon. The rich palette and use of opulent colours is typical of Preti's style and the high Baroque fashion of the seventeenth entury. St George is clearly seen representing the chivalry of the Aragonese knights. The little angel on the left holds the flag of the Aragonese langue.

The lunettes on either side of the chapel, also by Mattia Preti, show scenes from the life of St Lawrence. On the left St Lawrence is shown at the moment of his martyrdom, as he is being tied to gridiron to be burnt. The other shows St Lawrence meeting Pope Sixtus III. Beneath these two paintings are two more pictures: the one on the left represents *St Francis Xavier* and on the right *St Firminus*, protector of Navarre.

The main arch at the entrance is adorned with palms and laurels – symbols of peace and victory. The walls are also carved and gilded. They display some of the most exquisite designs of foliage and garlands, with cherubs frolicking amongst them.

There are four grand masters buried in this chapel. Facing the altar to the left there is the monument to Grand Master de Redin (1657-60) and opposite there is that of Grand Master Rafael Cotoner (1660-63). Both monuments are sober in character and conservative in design. Although not quite typical of the Baroque era, the tombs' designs seem to be particular to this church as there are more similar monuments. Grand Master Rafael was succeeded by his brother Nicolas whose monument is also in this chapel, to the left by the outer arch. The monument is particular on account of its eloquent artistic language. It could not be more different than his brother's. His gilt bronze bust is ensconced amongst an exuberant display of war trophies. He looks towards the high altar, clearly showing his faithfulness to the Catholic faith. Two slaves crouch underneath the weight of the weapons, representing the supremacy of the Order over Asia and Africa. The slave on the right is seen reacting to the trumpeting of the Angel of Fame. Nicolas, who wanted to be remembered as a faithful member of the Order as well as a Catholic warrior, reigned much longer than his brother – from 1663 to 1680. The cotton plant motif of his family coat of arms is frequently encountered as he was one of the church's great benefactors.

The other monument to the right is that of Grand Master Ramon Perellos y Roccaful (1697-1720). Its elegant design and monumental dimensions makes it one of the most exquisite monuments in the church. It was carved mainly in white marble in Rome by Giuseppe Mazzuoli. Two allegorical figures sitting on the sarcophagus, typical of the designs for

Opposite:
The Chapel of the
Langue of Aragon

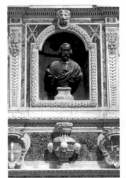

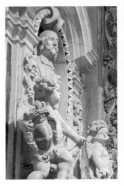

From top: Detail from the monuments of Grand Masters Ramon Perellos y Roccaful (1697-1720), Raphael Cotoner (1660-63), and Martin de Redin (1657-60)

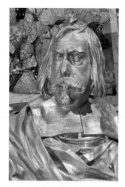

From top: details from the monuments of Grand Master Nicholas Cotoner (1663-80), a head of a slave (N. Cotoner), and Grand Master Ramon Despuig (1736-41)

Opposite: The monuments of Grand Masters Manoel Pinto de Fonseca (1741-73), and Anton Manoel de Vilhena (1722-36) in the Chapel of Castille

funerary monuments then popular in Rome, represent Charity and Justice. Charity holds an infant to her breast, whilst Justice holds a pair of scales. A little *putto* holding a *fasces* sits between the figures.

At the top of the monument the noble image of Grand Master Perellos, captured in a bronze bust, looks down approvingly. He is framed by a large marble medallion which is surrounded by two white marble olive branches, symbols of peace. The monument is crowned by a large armorial shield adorned with pears, the symbol of his family coat of arms.

The many masterpieces in this chapel include a miniature on the door of the tabernacle which depicts St Vincent Ferreri kneeling before Our Lord and carrying a portrait of Grand Master Perellos.

In this chapel were also kept several important relics of the knights. These included the arm of St George, the arm of St Vincent Ferreri, a relic of the True Cross, and the entire body of St Fidele, Martyr, which is kept in the altar of the chapel.

Like several of the other chapels, the chapel of Aragon is lavishly embellished with silverware. It is recorded to have had two torch holders, an altar front with a medallion of St Vincent Ferreri, a set of large candlesticks, and three large oil lamps as well as altar cards. These were seized by Napoleon in 1798.

The passageway between the chapels of Aragon and Castile commemorates various personalities. Here is to be found the oldest marble tombstone in St John's, that of the Knight Fra Jacques de Virieu Puppettieres who died in 1602.

The Chapel of the Langue of Castile

The Chapel of the Langue of Castile, Leon, and Portugal is dedicated to the patron saint of Spain, St James. The altarpiece, another work by Mattia Preti, depicts the saint in a most aesthetically pleasing manner; its earth colours and exquisite draughtsmanship make it a masterpiece of Baroque art. St James wears a scallop shell on his chest, which is his attribute as a pilgrim. The lunettes flanking the sides depict *St James banishing the Moors from Spain* and *St James kneeling at the feet of Our Lady of Pilar* respectively, both by Preti.

There are two grand masters buried in the chapel. On the left close to the altar is the monument of the Portuguese nobleman Grand Master Anton Manoel de Vilhena (1722-36) by the well-known Florentine sculptor Massimiliano Soldani Benzi who was employed by Cosimo de Medici as master of the mint in Florence.

The monument is a mixture of bronze and green marble and is beautifully animated with angels. At the summit, the Angel of Fame blows her trumpet whilst a cherub holds the shroud of death. The portrait of the grand master is supported by angels, whilst another four young angels sit on the sarcophagus mourning the death of the grand master. A relief in the centre of the sarcophagus depicts the grand master being presented with the plans of Fort Manoel which he had ordered to be constructed and which still bears his name.

The simple yet elegant monument commemorating Grand Master Pinto (1741-73) on the left close to the archway to the nave has a note of Neo-Classical restraint. It says little about the grand master who happened

26

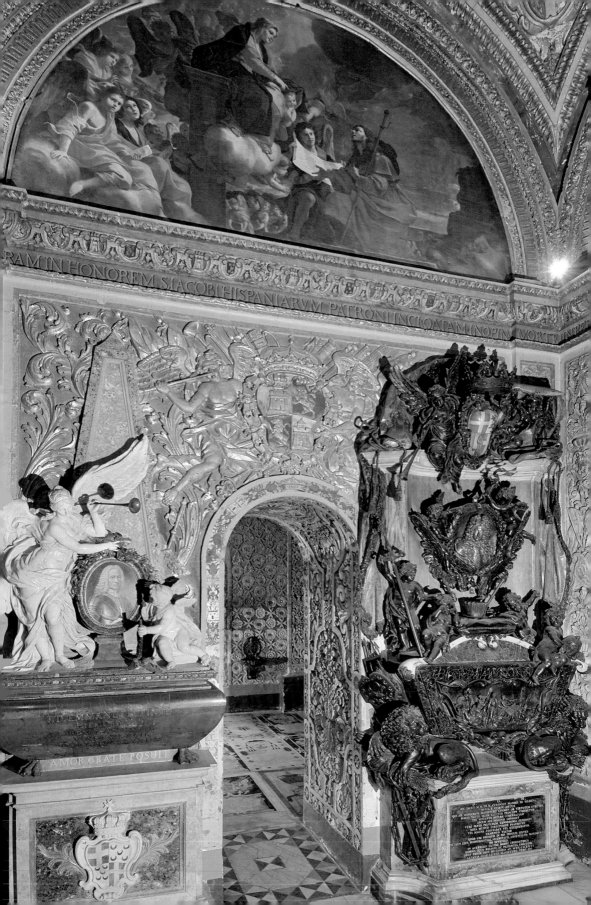

... RAM IN HONOREM S. IACOBI HISPANIARVM PATRONI INCLOATAM INOPIN · MORTE ...

D · EMMANUEL ... PINTO ...

AMOR GRATE POSUIT

D · O · M ·
HIC IACET ... FR · D · ANTONIVS MANOEL DE VILHENA
... REGIA ... ET ATQVE ORTVS VIRTVTE ...
... EXERCITIO EVECTVS
MAGNA NAT ...
... CARCERE

to be one of the most flamboyant rulers. He had declared himself the Prince of Malta and was the first to adopt the closed crown which can be seen on his coat of arms at the bottom. The sarcophagus is trimmed with precious stones and mounted with a mosaic portrait of Grand Master Pinto. On top rests the Angel of Fame, a masterly piece of sculpture in pure white marble. He is accompanied by a young angel who sits looking at the portrait of the grand master, whilst extinguishing a torch indicating the end of his master's life.

The Chapel of the Anglo-Bavarian Langue

This chapel, once known as the Shrine of the Holy Relics, became the Chapel of the Langue of England and Bavaria late in the eighteenth-century. It is dedicated to St Charles Borromeo, protector of the Order of St John, the renowned Catholic reformer. The altarpiece, representing the saint being presented to the Virgin Mary, is a fine expression of the refined late eighteenth-century Roman Classical trend and is attributed to Beaumont. The elegant design of the altar, made from fine polychrome marble, is also a typical expression of the High Baroque style. On top of the altar is an exquisite

bronze gilt crucifix from the workshop of Alessandro Algardi, the renowned Roman sculptor.

The gilt-stone altar reredos is a fine example of High Baroque sculpture and displays the high levels of Maltese stone carvers. It was made during the reign of Grand Master Lascaris whose coat of arms it bears. The reredos was adapted to hold two important and rare caskets containing saints' relics. Originally all the relics had their own reliquaries but these were removed during the French occupation in 1798.

Relics were very important during the time of the knights as relics drew great devotion towards the church in which they were kept.

The bronze gate surmounted on a marble balustrade once belonged to the chapel of Philermos where it served as an inconostasis. It was brought in this chapel after it was replaced with the silver gates.

The Chapel of the Langue of Provence

The Chapel of the Langue of Provence is dedicated to St Michael the Archangel. The altar is flanked by twin twisted columns placed on either side which are an example of the earliest altar designs in the church. The altarpiece depicts the saint as a young warrior in the act of banishing evil represented by a dragon. The representation in elegant Baroque style is typical of the new iconography given to St Michael after the Counter Reformation.

The funerary monuments in this chapel belong to Grand Masters Antoine de Paule (1623-36) and Jean Lascaris Castellar (1636-57). Both monuments are composed in inlaid marble in the elegant Late Mannerist

The holy body of St Clement, martyr, in an urn inside the 'Mensa' of the altar of the chapel

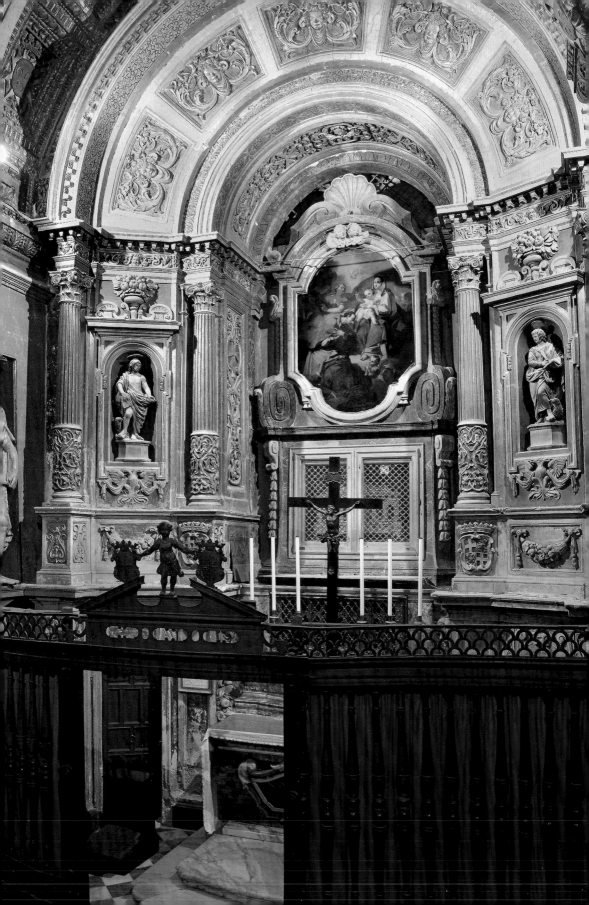

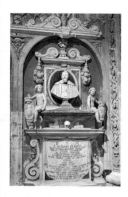

From top: Details of the monuments of grand masters Antoine de Paule (1623-36), and Jean Lascaris Castellar (1636-57)

Opposite:
The Chapel of the Langue of France

The altarpiece of the Chapel of the Langue of Provance dedicated to St Michael the archangel

style, typical of the style favoured by the Order in the first half of the seventeenth century. A low-relief composition above the monument of Grand Master Lascaris depicts an allegory of the Order's victory over the Turks. The side lunette represents the *Apparition of St Michael on Mount Gargano*.

In the cupola of the chapel there is the coat of arms of Grand Master La Cassiere and in its eight segments, there is a carved crown with fleurs-de-lys, a symbol of the French knights of which the langue of Provence formed part. In the four pendentives of the cupola are four escutcheons; the two near the altar are those of the Order and of Grand Master Cotoner respectively. The two near the nave are those of Grand Commander Jean Jacques de Verdelin with that of the langue of Provence on the left. The wall carvings of this chapel contain a bird which is part of the emblem of Jean Jacques de Verdelin, a benefactor of the chapel.

The Chapel of the Langue of France

The chapel of the langue of France was dedicated by Grand Master La Cassiere himself to the Conversion of the Great Apostle St Paul. The entire chapel was profusely decorated with rich sculptural motifs and gilded during the 1660 redecoration of the church. It underwent further redecoration in the nineteenth century. The generous distribution of fleurs-de-lys in the passageway, as well as on the interior walls proclaim the supremacy of the French crown. The dome of the chapel is also profusely

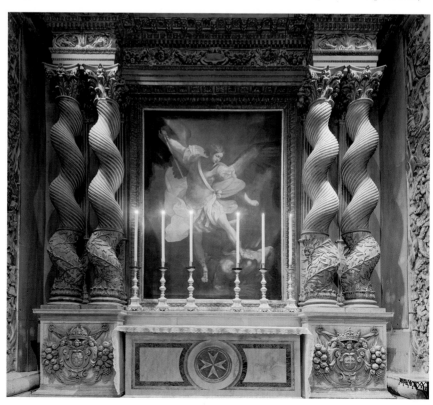

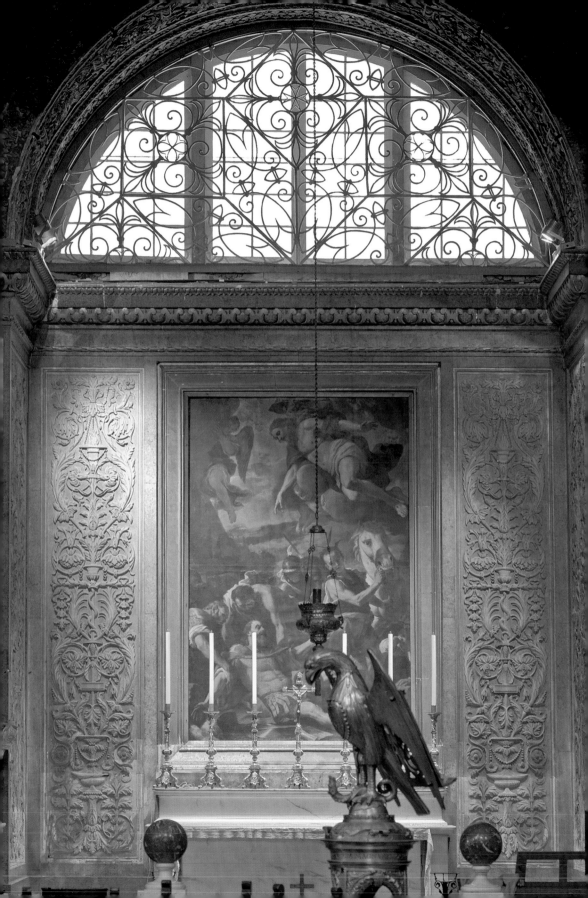

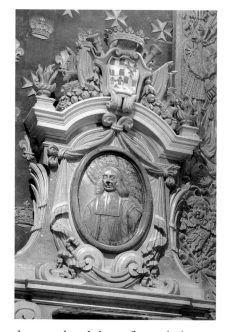

Grand Master Adrian de Wignacourt (1690-97), detail from his monument

Wignacourt's coat of arms, from the frieze in the chapel

Opposite: The monument of Grand Master Emmanuel de Rohan (1775-97)

Grand Master Claude de la Sengle (1553-57) coat of arms, from a frieze in the chapel

decorated with large fleurs-de-lys crowned and supported by two angels. The walls were decorated in 1838 with the crowned cross of St John representing the Order and the fleur-de-lys of the langue of France.

The outer arch of the chapel is decorated with garlands of flowers, together with the cross of the Catholic faith and the cotton plant of Cotoner. In the centre of the archway is a large medallion with the arms of France held by two angels and a variety of war trophies. The main columns of the chapel are enhanced with intricate designs, all beautifully carved in stone and gilded. Seen on the pilaster is an angel gathering flowers, laurel, and olive branches, all symbols of victory, with the inscription *ego in deliciis*. On the other side, is an angel with the escutcheon of France and accompanied by an inscription *imperium sine fine dedi*. Another angel carved into the walls sounds the trumpet of victory whilst trampling upon the arms of the enemy.

The centre of the dome holds the lion of La Cassiere similar to the other chapels'. It bears the inscription *aspicit iste leo Cassera sed efficit alta 1576*. The eight segments of the dome are carved with the letter L for Louis and the fleur-de-lys with a royal crown. The four spandrels beneath the dome are embellished with the coats of arms of the four grand masters of the langue of France: L'Isle Adam, Wignacourt, Naillac, and la Sengle

The altar is a simple and elegant work in white marble. The altarpiece depicts *The Conversion of St Paul on the Way to Damascus* by Mattia Preti. The paintings decorating the lunettes depict *The Shipwreck of St Paul in Malta* and *The Beheading of St Paul in Rome*, both by the German artist Lukas Kilian.

The altar and reredos were originally installed 1614 as an inscription in the chapel testifies. They were in the then current Baroque style. The walls were also

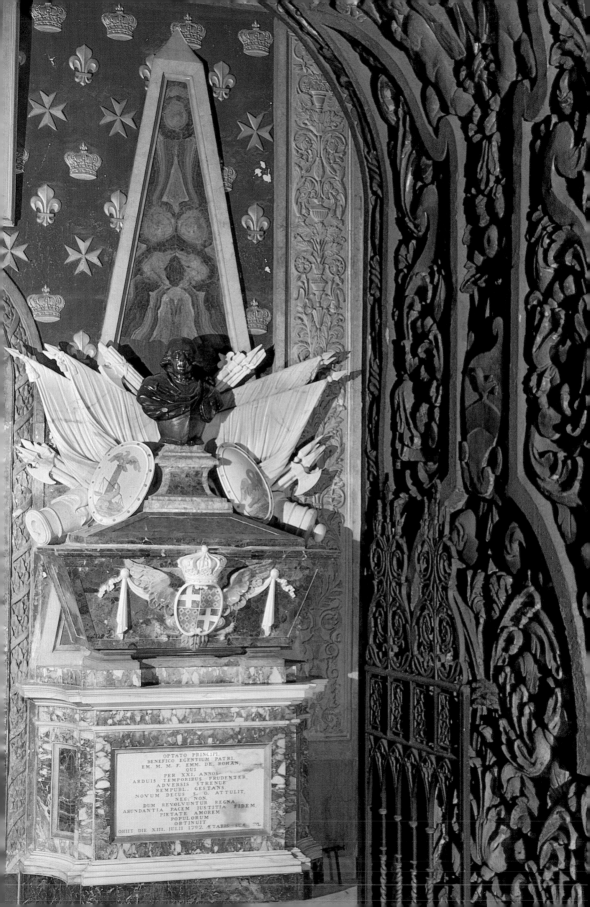

OPTATO PRINCIPI,
BENEFICO EGENTIUM PATRI,
EM. M. M. F. EMM. DE ROHAN,
QUI
PER XXI. ANNOS
ARDUIS TEMPORIBUS PRUDENTER
ADVERSIS STRENUE
REMPUBL. GESTANS
NOVUM DECUS S. O. ATTULIT,
NEC NON,
DUM REVOLVUNTUR REGNA,
ABUNDANTIA PACEM JUSTITIA FIDEM,
PIETATE AMOREM
POPULORUM
OBTINUIT
OBIIT DIE XIII. JULII 1797 ÆTATIS SUÆ 72.

The monument of Vicomte de Beaujolais

carved with the letter L, the royal crown, and the fleur-de-lys, the arms of the langue. In 1838 they were remodelled into beautiful foliage designs in low relief of white stucco to fit the current Neo-Classical ideals. The Ls from the walls were also removed and replaced with the arms of the Order and of the langue of France.

The chapel holds three magnificent funerary monuments. The monument to Grand Master Adrien de Wignacourt (1690-97), the nephew of Grand Master Alof de Wignacourt (1601-22) is sited on the epistle side. It is made out of white marble surmounted by his coat of arms with an open crown accompanied with the trumpet and banners of Fame. A festoon of flowers and fruit is gracefully draped above the cornice. In the centre of the monument is a gilded bronze oval with a low-relief portrait of the grand master. The remains of the grand master lie in a black marble urn which holds an inscription in praise of his virtues and achievements.

The pure-white-marble monument of Grand Master Fra Emmanuel de Rohan (1775-97) is situated on the right of the altar. The urn, with his coat of arms emblazoned on it, holds his remains. Placed on a marble pedestal is the grand master's bust cast in bronze accompanied with a beautiful display of war trophies. Two shields rest upon it, one bearing an eagle and the scales, symbols of Virtue and Justice, whilst the other holds the image of a pelican, a symbol of Charity.

The monument to the left of the altar is that of Marquis de Wignacourt, the brother of the grand master, who fell ill and died here during a visit in 1615. It consists of

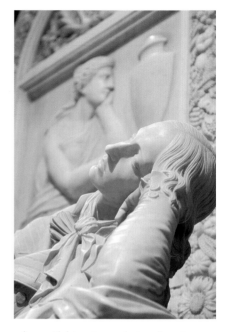

a beautiful intricate design forming a catafalque made up of inlaid marbles and is surmounted by the arms of the Wignacourt family. It was erected by Grand Master Aof de Wignacourt in memory of his brother.

The most interesting monument to be found in this chapel is that of Vicomte de Beaujolais, the brother of King Louis Philippe of France, who died on 29 May 1808 while he was in Malta. The monument is in pure white marble and was erected on behalf by the king himself. The marble plaque at the rear of the monument marks his burial place. The reclining figure of the count was commissioned by the king in 1843 from the French sculptor Jacques Pradier.

The marble inlaid tombstones in the chapel commemorate several distinguished knights. These are Fra Rene Le Vexel du Tertre, Fra Claude de Saint Simon, Fra Henri de Chastellet de Moyencourt, Fra Jean de Fresnoy, Fra François de Vion de Thessancourt, Fra Baudouin

Coat of arms of the Italian langue, in the Chapel of Italy

de Crulart de Genlis, Fra Jacobe Chevestre de Cintray, Fra Henri d'Estampes de Valencey, and Fra François Jacques Calan.

The Chapel of the Langue of Italy

The chapel of the langue of Italy, dedicated to the Immaculate Conception and St Catherine of Alexandria, the patron saint of the Italian knights, is remarkable for its artistic splendour and is a true expression of the Baroque concept of totality where architecture, sculpture, and painting are conceived as one aesthetic whole. The chapel was decorated at the personal expense of Fra Francesco Sylos, ambassador to the viceroy of Sicily and commander of Palermo and Agrigento.

The decision to embellish the chapel was taken on 5 July 1660 when a proposal was presented to the council by Fra Francesco Sylos. No time was wasted as, on that same day, Michele Casanova and Pietro Burlo, two sculptors from Senglea, were commissioned to start the carving of the arches and pilasters and were told to finish the work by the following October. In all probability, they followed designs prepared by Mattia Preti. The moulding of the cornice was decorated with scallops and crosses, symbols from Sylos's coat of arms. The pendentives of the dome hold four escutcheons: that of the Order and of Grand Master Raphael Cotoner above the altar, whilst the two on the side of the nave represent the langue of Italy.

The inner walls of the arches were decorated with exquisite acanthus leaves as a reference to the grandeur of Classical antiquity, garlands of fruit as

symbols of the bountiful reign of the grand master, whilst the double-headed eagle is a sign of the magistracy of the Spanish crown. The RC motifs refer to Grand Master Raphael Cotoner. Carved in the central medallion of the dome is the date 1576.

The elegant architectural structure of the altar and reredos were made in 1733 to the design of Romano Carapecchia (1668-1738), who was an apprentice of Carlo Fontana – one of the most capable architects of the Roman Baroque

The monument of Grand Master Gregorio Carafa (1680-90)

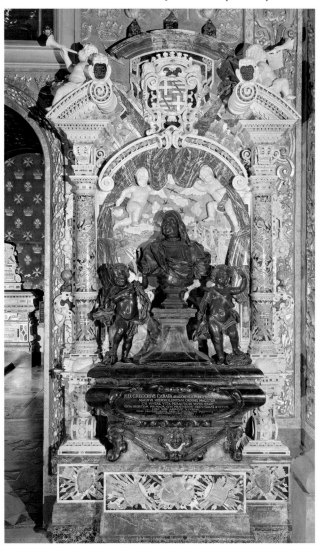

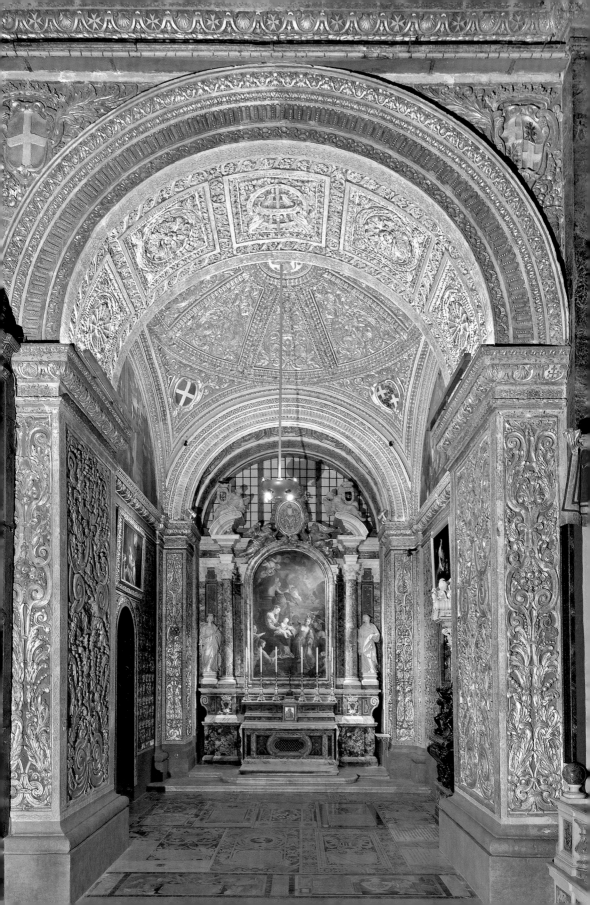

era. The altar consists of finely carved polychromized marble and is raised on three steps. The relics of St Euphemia are visible through an oculus on the altar front. The tabernacle door is an icon of the Virgin and Child. The altar is backed with a large broken pediment and two columns; these are flanked by the marble statues of St Catherine and St Euphemia standing on large scrolled corbels. The entire group is crowned with four angels carved in wood. Two gilt angels accompany the central medallion that originally held the image of Our Lady of Carafa, now kept in the chapel of Our Lady of Philermos. The two other gessoed angels rest on the broken entablature.

The polychrome marble monument of the Italian Grand Master Gregorio Carafa (1680-90) depicts intricate designs of several war trophies. The sarcophagus is in black marble and carries the bronze bust of the grand master accompanied by two putti, crushing a turban and a skull under their feet respectively. In the background two other putti are drawing back curtains revealing a battle scene in polychrome marble. This is the Battle of the Dardanelles fought in 1656 in which Carafa played a leading role. The monument was installed in 1688, as noted in the inscription. It is attributed to Ciro Ferri (1634-89), an apprentice and a follower of Pietro da Cortona, the author of the gilt silver and bronze reliquary of St John's arm, once placed in this church.

The Altar Painting
The Chapel of Italy is adorned with several important Baroque paintings. Fittingly the altarpiece is dedicated to St Catherine of Alexandria, the patron saint of the Italian langue.

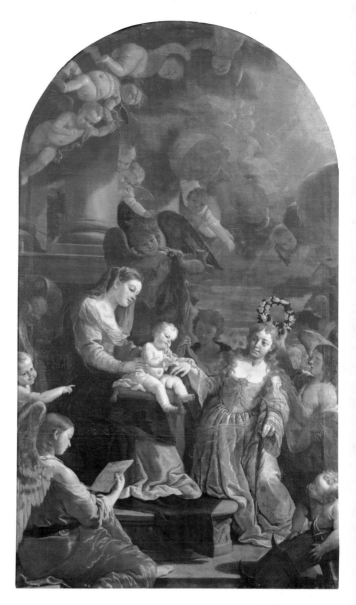

It depicts *The Mystic Marriage of St Catherine* and is the work of Mattia Preti. In May 1670 the langue commissioned the gilding of the stone frame carved round the altarpiece.

The paintings in the lunettes were also commissioned by Fra Francesco Sylos when the chapel was undergoing redecoration in the mid-17th century and are emblazoned with his coat of arms. They depict *St Catherine disputing with the Philosophers* and *The Martyrdom of St Catherine* respectively

Mattia Preti, *The Mystic Marriage of St Catherine*, altarpiece of the Chapel of Italy

On the left: The Chapel of the Langue of Italy

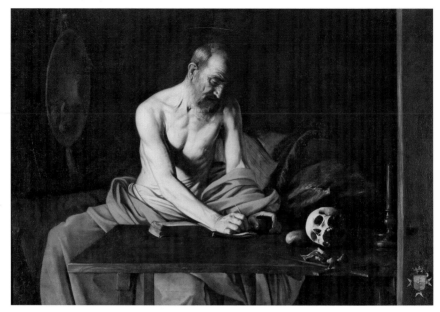

Caravaggio, *St Jerome writing*

St Mary Magdalene, a copy from Correggio

St Jerome *and* The Penitent Magdalene

These paintings originally formed part of the private collection of Fra Ippolito Malaspina, an important and powerful member of the Order, and were donated to St John's after his death in 1624. The painting of *St Jerome writing* by Michelangelo Merisi da Caravaggio is today kept in the oratory of the Co-Cathedral. It once adorned this chapel of Italy and hung above the passageway to the chapel of France.

Caravaggio, who fled to Malta accused of murder, spent just over a year on the island, from July 1607 to October 1608. Caravaggio entered the Order as a knight of obedience and was obliged to spend a year in the convent. In all probability he was commissioned this work directly by Malaspina and it was intended to adorn the walls of his house in Valletta. St Jerome, who was known for his asceticism, was a subject that a knight of the calibre of Malaspina would want to be associated with. The saint is represented as an old man, grave and dignified. The lack of over-dramatized actions and the restrained palette gives the painting a distinctive Maltese flavour as it reflects the serenity Caravaggio enjoyed as a short-lived member of the convent.

The Penitent Magdalene is a faithful copy of a detail from a well-known work by Correggio in Parma which depicts the *Lamentation of the Death of Christ*. This work most probably belongs to the late sixteenth century. In all probability it was executed in Italy and brought over to Malta as part of Malaspina's personal collection.

The Penitent Magdalene was a popular subject in the post-Catholic Reformation years. This painting was certainly enlarged on either side to correspond, more or less, with the dimensions of the *St Jerome*. Originally both were hung in the lunette spaces: the holes in the walls which held the original hooks correspond exactly with their dimensions. These details were revealed during the course of restoration. The *Penitent Magdalene* was again enlarged in 1661 when the chapel was undergoing decoration as two new elaborate frames were ordered for the two works by the procurators of the langue of Italy. It must have been at this stage that it was realized that the canvas of the Magdalene was smaller by a few centimetres and it was enlarged yet again to fit the new frame – this time only to the left of Magdalene's side. To support this conclusion, the canvas of the first and second enlargements are of different manufacture. The quality of the draughtsmanship and brush work in the two separate interventions also show the work of different hands as was revealed during the course of restoration. Bellori in his *Vita*, published in 1672, describes the chapel as having two paintings by Caravaggio. It must have been their similar dimension and symmetrical positions and the fact that both works bore the Malaspina coat of arms that made him reach this conclusion.

Another two paintings, the *Holy Family* and *St John the Baptist*, were also donated to the chapel by Malaspina. They originally hung just above the passageways to the adjoining chapels. These were replaced by the *St Jerome* and the *Magdalene* and were moved to the chapel of France during the redecoration process.

The floor of the chapel consists of richly inlaid marble tombstones that date to the seventeenth and eighteenth centuries. The distinguished knights commemorated include Leone Strozzi, Pompeo Rospigliosi, Francesco Piccolomini, and Ippolito Malaspina.

Between 2004 and 2006 the entire chapel underwent extensive restoration made possible by the Italian government.

The Chapel of the Langue of Germany

This chapel was originally assigned to the langue of England when it had *The Flagellation* by the Florentine artist Stefano Pieri as its altarpiece.

The tombstone of Fra Ippolito Malaspina

Detail from the vault carvings in the Chapel of the Langue of Germany

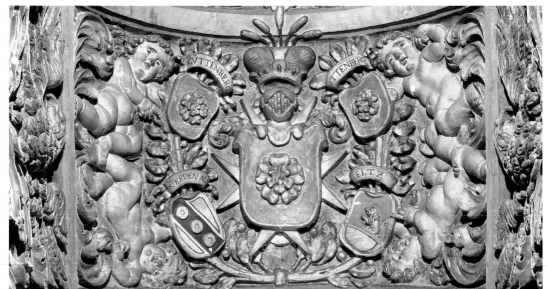

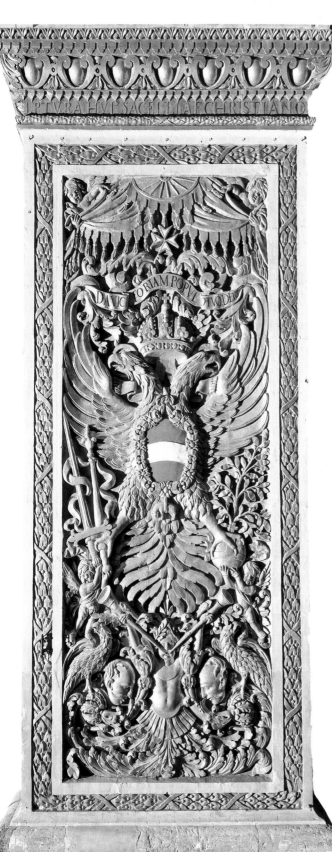

However, after England broke away from Rome, the chapel was reassigned to the langue of Germany and dedicated to the Epiphany. The langue included knights not only from Germany but also from Austria, Norway, Sweden, Denmark, and the Netherlands. It was also established that, should England be reconciled with the Church, the council would allocate to the English langue another chapel appropriate to its seniority.

The paintings in this chapel, all dating to the late seventeenth century, and typical of the Baroque style, are by the Maltese artist Stefano Erardi who came from a family of well-known artists. The altarpiece, *The Adoration of the Magi*, depicts the moment when according to the Bible the three wise men from the East who came to the place of Christ's birth guided by a bright star. The delicate decorative effects, such as the group of angels, give it a most pleasing effect. The semi-circular paintings in the lunettes high above the passageways depict *The Nativity of Christ* and *The Massacre of the Innocents*. The walls are covered with intricate designs carved into the soft Malta stone showing various types of weapons. They are symbolic of the military role of the Order. The double-headed eagle is the emblem of the German langue.

Worthy of note are the two gilded coats of arms in the ceiling of the passages. The passage leading to the sacristy holds the coat of arms of Baron Fra Wolfgang Philipp von Guttenberg, bailiff of Brandenburg, a great benefactor of the Order. He died on 4 December 1733 and is buried beneath tombstone no. 184.

One of the carved pillars in the Chapel of the Langue of Germany
Opposite: The Chapel of the Langue of Germany

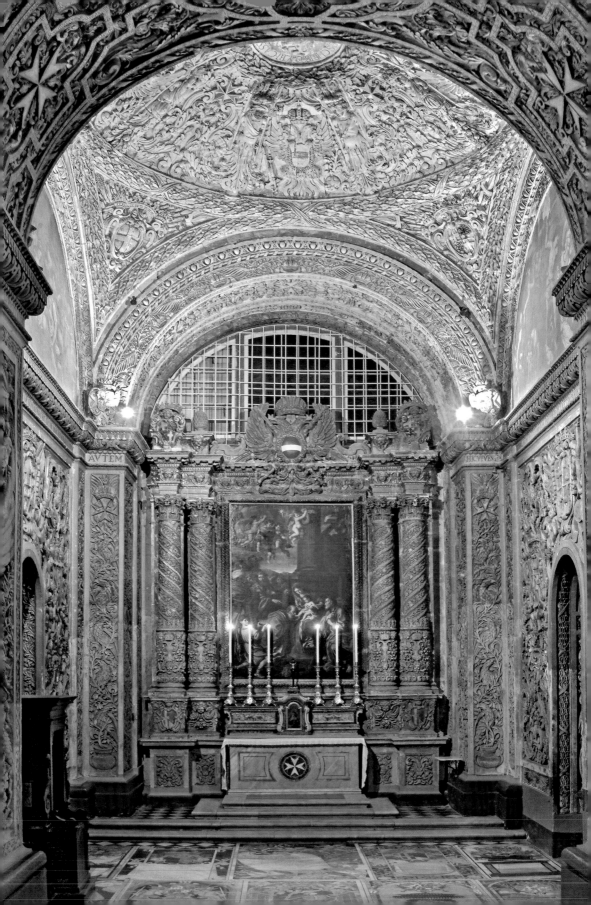

THE SACRISTY

The Sacristy

The sacristy is reached through the last chapel on the north side. It was built in 1598, 21 years after the church was completed, when Grand Master Garzes realized the need for a sacristy. It was completed in 1604 under Fra Raymondo de Vere's charge thanks to the funds left by the bailiff of Majorca whose coat of arms are displayed in the centre below the niche above the altar. Its coffered barrel vault gives an impression of the original appearance of the main vault of St John's before it was transformed by Preti in the 1660s. The private quarters of the sacristy, which included the treasury, were embellished in 1758 by Grand Master Pinto.

The main altarpiece is the highlight of this elegantly proportioned space. It depicts *The Flagellation of Christ* when, according to the gospel, Pontius Pilate, the governor of Judea, ordered Jesus to be flogged just before he was led away to be crucified. This moment of Christ's suffering became important in Catholic Reformation art. It became customary to show Christ bound to a column being flogged by his tormentors. This altarpiece is the work of Stefano Pieri. During recent restoration an inscription showing his name and the date 1572 was revealed. The iconography is a popular version based on a drawing by Michelangelo.

The portraits in the sacristy include *Pope Benedict XIV* by Antoine Favray (1706-98) which is a copy of the Lambertini pope by Pierre Subleyras and *Pope Clement XI* by the Maltese artist Alessio Erardi. Opposite hang the portraits of *Grand Master la Cassiere* ordered by the *Veneranda Assemblea* in 1618 and *Grand Master Raphael Cotoner*, probably painted during his reign.

Hanging from the cornice are the Colours of the Battalions of the Royal Malta Regiment.

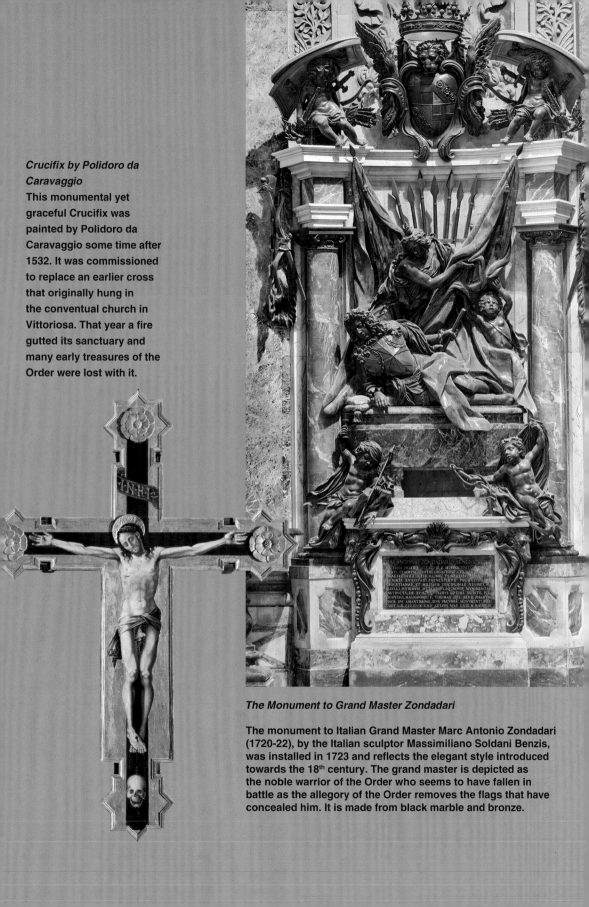

Crucifix by Polidoro da Caravaggio

This monumental yet graceful Crucifix was painted by Polidoro da Caravaggio some time after 1532. It was commissioned to replace an earlier cross that originally hung in the conventual church in Vittoriosa. That year a fire gutted its sanctuary and many early treasures of the Order were lost with it.

The Monument to Grand Master Zondadari

The monument to Italian Grand Master Marc Antonio Zondadari (1720-22), by the Italian sculptor Massimiliano Soldani Benzis, was installed in 1723 and reflects the elegant style introduced towards the 18th century. The grand master is depicted as the noble warrior of the Order who seems to have fallen in battle as the allegory of the Order removes the flags that have concealed him. It is made from black marble and bronze.

THE ORATORY

Opposite:
The Oratory

On next page:
Caravaggio, *The
***Beheading of St**
John the Baptist

**The doorway
to the Oratory
by Romano
Carapecchia**

The oratory, a place of devotion for young novices, was started in 1602 and must have been finished by 1605 when, as records in the archives state, its windows were fitted with glass – then still a rare commodity. Grand Master Alof de Wignacourt was searching for an artist to embellish the new palaces and the conventual church, and to produce a painting of the martyrdom of St John, the patron of the Order, for the novices to meditate on and to impress on their young minds the devotion required to be a virtuous knight. This is how

Michelangelo Merisi da Caravaggio, better known as Caravaggio, came to Malta. When he first stepped into the oratory, it was still a simple and plain rectangular construction.

Before coming to the island, Caravaggio was working in Rome where he had already acquired a high reputation as an artist. However, after being involved in a violent quarrel during which he fatally wounded his opponent, he fled Rome and headed for Naples, waiting for a pardon from the pope which he hoped to acquire through his powerful patrons. He soon took the opportunity to come to Malta on the galleys of the Order, arriving here on 12 July 1607. He was probably attracted not only by the patronage of the Order but also by the dream of knighthood. At first his fortunes were good and he was warmly welcomed on the island. His outstanding paintings produced within his short stay of just 15 months are a testimony of his well-being and emotional stability.

After having spent a year as a novice within the convent, he was invested into the Order on 14 July 1608, a ceremony that took place here in the oratory. Now free to leave the convent, it was not long before he got into trouble. A few weeks later, Caravaggio was involved in a fight during which a high-ranking knight was seriously wounded. Caravaggio was arrested and imprisoned at Fort St Angelo. Disgraced and unable to paint, he used his inventive powers to plan a daring escape. Caravaggio's incredible breakaway took place in October 1608 and once again he was on the run. The council, informed of his disobedience, immediately expelled him from the Order.

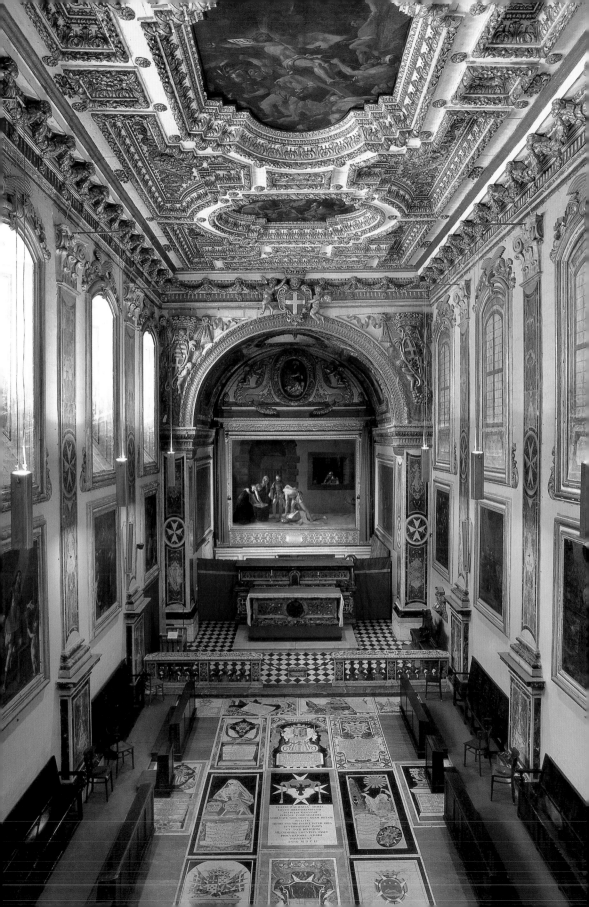

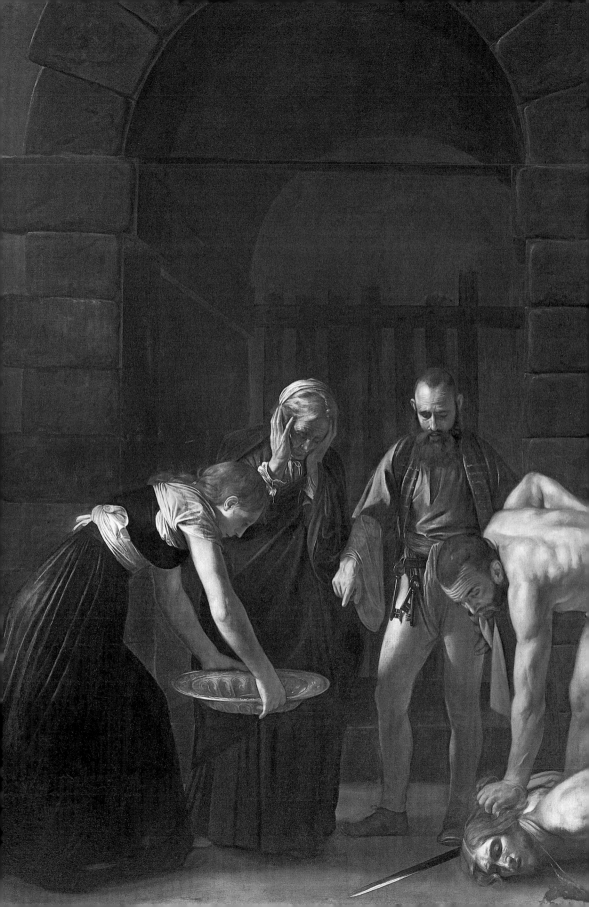

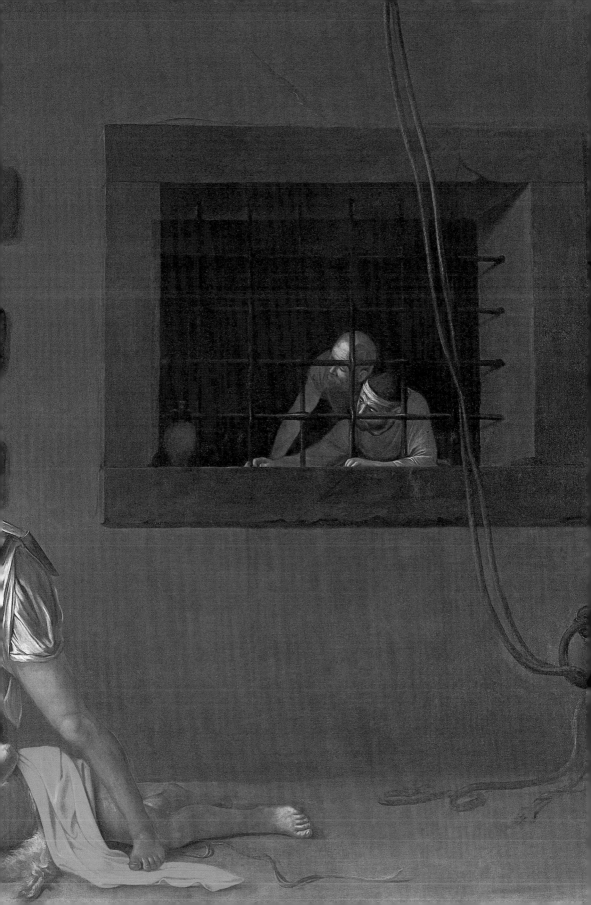

Detail of the signature of Caravaggio from *The Beheading of St John the Baptist*

Detail of the two prisons behind bars from *The Beheading of St John the Baptist*

The Beheading of St John the Baptist

The *Beheading* is Caravaggio's largest and the only painting which bears his signature scrawled in the blood flowing from the Baptist's throat. Caravaggio is best known for his revolutionary light effect called *chiaroscuro* and harsh realism which soon became hallmarks of Baroque painting. St John had been arrested and imprisoned for having reproved King Herod for his illicit marriage to Herodias. Angered by his condemnation, Herodias schemed for John's death. At the banquet on the king's birthday, Salome, daughter of Herodias, so delighted Herod by her dance that he offered to grant her anything she desired. Instructed by Herodias, she asked for the Baptist's head. Immediately an executioner was sent, and John was beheaded.

This is the moment that Caravaggio chose to immortalize. The characters in this painting, unlike his earlier works, especially those he executed in Rome, are less violent and dramatic and no longer leap out of the picture plane. In the *Beheading*, the protagonists fit comfortably in the picture space. Each

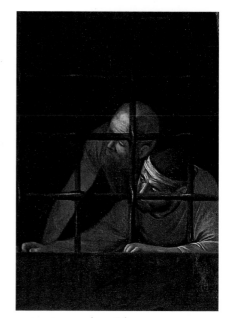

action is complete. The young woman on the far left, perhaps Salome's maid, holds a large platter to receive the severed head, whilst the old woman, the only character who shows some emotion puts her hands to her face in horror. The cold yet handsome janitor points downwards as he instructs the executioner to finish the job. On the right, two prisoners gaze intently at the scene. Here Caravaggio's special effects can be observed: the manner with which the characters are immortalized by the crisp and realistic rendition of their anatomy and the sparse use of colour. He intentionally uses a restricted palette of browns with a single splash of red reserved for St John's mantle. He skilfully contrasts youth and old age and the naked back of the executioner with the janitor's rich green velvet jacket. The painting is washed in a beam of golden light giving it a theatrical character. Caravaggio excluded any divine intervention: there are no angels descending from the skies and no halo for St John. Instead he focused on mankind's tragic fate.

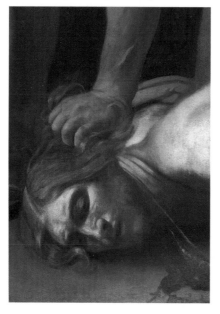

Detail of the severed head of St John from *The Beheading of St John the Baptist*

It is ironic that Caravaggio, today a much celebrated artist, was defrocked and expelled from the Order in a ceremony which was held in the oratory in the presence of the venerable council and in front of the *Beheading of St John the Baptist*, the work he had so proudly, and perhaps even defiantly, signed *Fra Michelangelo*.

St Jerome

Caravaggio may have been commissioned the painting of *St Jerome* directly by Fra Ippolito Malaspina, an important Italian knight, and it was intended for his house in Valletta. Caravaggio depicts the saint as an old man, grave and dignified. It is one of the most personal and introspective works he produced in this period.

St Jerome is best known for translating the Bible from Greek into Latin. He is shown seated, perched on the edge of his bed, writing. The brilliant flesh tones of his bare chest strike a sharp contrast with the deepening darkness of the background. The weathered flesh of the saint's face and hands contrast with the deep folds of his rich, red gown – the only true colour in the painting. On the table is one modest volume in which he is writing. Placed close to the edge of the table are a stone, a skull, and a crucifix, reminders of penance, the ephemeral nature of worldliness, and meditation respectively. In the background hangs his cardinal hat. The coat of arms are those of Fra Ippolito Malaspina, after whose death this painting was donated to the chapel of Italy.

The oratory was given its present appearance by Mattia Preti in the 1680s when he installed the Venetian style gilt soffit and the paintings hanging on the walls. The embellishment was all paid for by Fra Stefano Maria Lomellini, the prior of the dormant langue of England. Above the *Beheading* is a wooden carved relief of Our Lady of Sorrows with swords thrust through her heart in a posture of agony. The ceiling was fitted with an exquisite soffit carved in wood and gilt. The paintings depict *Christ crowned with Thorns*, the *Ecce Homo*, and the *Crucifixion*.

Prior Lomellini commissioned ten paintings to adorn the walls. The two paintings on the left of the altar represent the first two rectors of the Order, the Blessed Gerard and Raymond kneeling before St John the Baptist. The paintings opposite show Agnes, the first abbess, and nuns of the Order kneeling before Our Lady. The other paintings depict important saints of the Order.

Worthy of note is the fine marble altar installed by Grand Master Carafa with its fine gilt bronze medallion by Ciro Ferri depicting the beheading of St John. To the right of the altar is an exquisitely carved marble head of the Baptist, the gift of the prior of Aix, Jean Melchior Alpheran as his passage into the Order in 1736. The marble balustrade in front of the altar is in itself a work of art. Note especially the delicate inlaid marble design, the work of Messinese and local craftsmen renowned for this type of delicate work.

The oratory organ is a unique work of art. It is a late sixteenth-century instrument of South Italian provenance. It is richly carved with late Renaissance gilt motifs. Originally the church's main organ, it was brought into the oratory after two new organs were installed in the seventeenth century by Grand Master Nicolas Cotoner. Between 2004 and 2006 it was completely restored with funds provided by the Italian government.

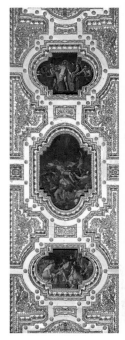

The wood ceiling of the Oratory, including Mattia Preti's painted scenes from the passion of Christ

THE CRYPT OF THE GRAND MASTERS

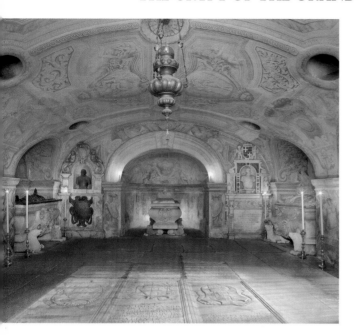

The grand masters of the Order of St John came to be known, in later years, as sovereigns, noble men of great power who governed over the group of *religiosi*, simultaneously sustaining both the military and more importantly, the religious facets of the Order. They were honoured by being buried beneath the High Altar of their very own Conventual Church in Valletta.

The Crypt was excavated beneath the high altar and is reached through a flight of steps within the chapel of the Langue of Provence. Within lie the remains of twelve grand masters who ruled Malta between 1530 and 1623. Almost bare in all its sobriety the grand masters' crypt forms a harsh contrast with the Baroque glory above as it evokes and celebrates the staunch religiosity of these leaders. In the four arches the tomb of Grand Master Philippe Villiers de L'Isle Adam (1521-34) can be found, the sarcophagus of which was designed

by Antonello Gagini from Sicily (1478-1536) and dates from 1534. In the next arch lies the tomb of Grand Master Jean de Valette (1557-68) who became one of the most celebrated Grand Masters of the Order after leading the island to victory during the Great Siege of 1565. The city of Valletta is named after him. The next tomb is that of Grand Master Jean Levesque de la Cassiere (1572-81), the founder of the Conventual Church of St John. Under the other arch there is the tomb of the Grand Master Cardinal Hugues Loubenx de Verdalle (1582-95).

The four corners of the crypt are home to the tombs of Grand Master Alof de Wignacourt (1601-22), Grand Master Pietro del Monte (1568-72) and the beautifully carved Mannerist tomb of Grand Master Martin Garzes (1595-1601). Beneath the flooring are the tombs of Grand Master Claude de la Sengle (1553-57), Grand Master Pierino del Monte (1534-35), and Grand Master Juan de Homedes (1536-53). Grand Master Francisco Ximenes de Texada is buried beneath the pavement without a single line to mark the spot where he lies. Furthermore a small marble tablet commemorates the English knight Sir Oliver Starkey, the uditore and Latin Secretary of Grand Master de Valette, who is also buried in this crypt.

The ceiling of the crypt bears a fresco painting representing Man's creation, his fall and his resurrection by Nicolo Nasoni of Siena (1691-1773). At the eastern end of the crypt there is a stone altar on which stands a carved wood, early sixteenth-century group of the Crucifixion with two angels in adoration on either side.

THE MUSEUM

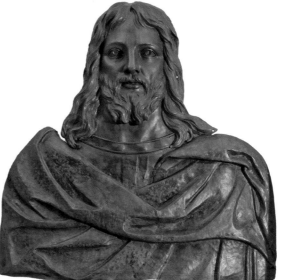

The monumental bronze cast depicts the image of *Christ the Saviour*. It was commissioned from Alessandro Algardi, a renowned Bolognese sculptor working in Rome, by Fra Alessandro Zambeccari as a sign of gratitude to the grand master who had granted his request for an ambitious promotion within the Order.

The statue arrived in Malta in August 1639 and was originally installed in a large free-standing niche at the Grand Harbour. Originally, Christ the Saviour held a globe in one hand, while the other was raised to bless all those who arrived and departed by sea.

Around 1712, the niche was removed and the statue placed on the façade of a newly built church along the quay. In 1853, this church was pulled down and the sculpture was placed on the pediment of the façade of St John's Co-Cathedral. In the process of one of these re-installations, the statue was remodelled. The original torso and hands were removed and a drape added, as can be seen in its present arrangement.

The sculpture has recently undergone restoration and for conservation reasons is kept here in the Museum. A copy is placed on the pediment of the façade.

The Choral Books

This rare and unique collection of illuminated manuscripts in the museum relate to the early part of the Order's stay in Malta. They consist of some of the most beautifully executed illuminated choral books of the sixteenth-century. The collection consists of three sets, all gifts of different grand masters.

The largest and most important set consists of 10 choral books, the

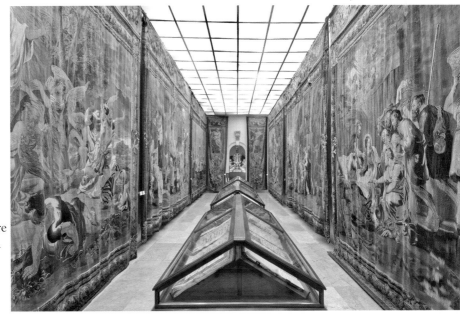

gift of Grand Master L'Isle Adam whose coat of arms is displayed frequently on the various folios. This set of choral books, called graduals, contains chants to accompany the communion service. Each choral book features large historiated or inhabited initials of exceptional beauty. The illuminations were painted on a gold leaf background to add brilliance to the colours and the image. These splendid miniatures, as they are called because of their minute detail, were executed by different artists, reflecting the current artistic trend of each artist. The result is an unusual mixture of Gothic and Renaissance styles.

The period of their execution and their provenance have been a subject of debate amongst historians. However, the choral books themselves reveal some knowledge. Hidden within a decorated initial is the date 1533 found together with the motto of the Order, *Pour le foy* meaning 'For the Faith'.

Included in this collection is a set of seven choral books bearing the arms of Grand Master Verdalle. The Verdalle choral books are referred to as antiphonaries, and contain the proper and common of saints. They also hold the sung parts of the divine office which are musical sections used during daily services at the various canonical hours of the day that do not feature in graduals. All are on parchment and contain 150 illuminated initials each.

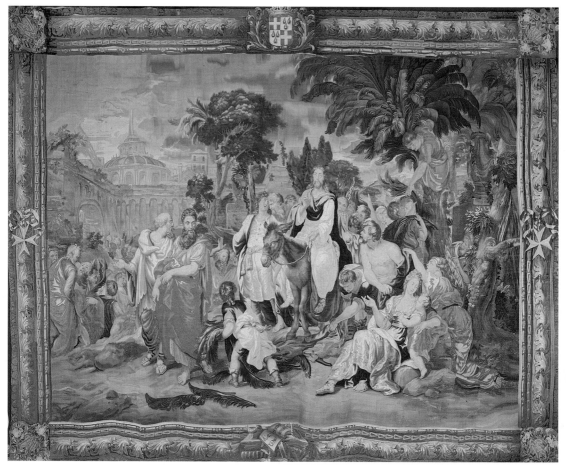

ST JOHN'S CO-CATHEDRAL

The illuminated manuscripts, the gift of Grand Master Antoine de Paule (1623-36) consists of two manuscripts in parchment. They are antiphonaries for the Temporal cycle of the liturgical year. They too contain miniatures of exquisite designs.

The Flemish tapestries
The Flemish tapestries at St John's form the largest complete collection in the world. The set consisting of 29 pieces was ordered from the Brussels *atelier* of Judecos de Vos for 40,000 *scudi* and was based on cartoons by Peter Paul Rubens. The Co-Cathedral was originally the conventual church of the Order of St John of Jerusalem. Tradition required that, on his appointment, a new grand master would present the church with a gift or *gioia*.

This set, the gift of the Aragonese Grand Master Ramon Perellos y Roccaful who was elected in 1697, had reached Malta by 1701. The entire set consists of 14 large scenes depicting the life of Christ and allegories and 14 panels representing the Virgin Mary, Christ the Saviour, and the Apostles. This grand set portrays the principal and fundamental divine truths of the Catholic faith and were intended to convey a message, that is, the supremacy of the Catholic Church and the fame and grandeur of the grand master and the Order. The set also includes a tapestry portraying the donor, Grand Master Ramon Perellos y Roccaful. The tapestries were originally suspended

from the main cornice along the nave of the church during important occasions, such as the feast of St John the Baptist.

The Monstrance for the Relic of St John
This gilded bronze and silver monstrance was made to house the relic of St John the Baptist's forearm. It was a most precious relic for the Order as this was the relic of the hand that had baptized Christ in the river Jordan. The monstrance was ordered by Italian Grand Master Gregorio Carafa, whose coat of arms is prominently displayed. It was cast in Rome by Ciro Ferri, a well-known sculptor whose style was particularly influenced by the leading Baroque sculptor, Gianlorenzo Bernini. The relic had a golden reliquary studded with precious stones which was, however, seized by Napoleon in 1798 when he invaded Malta. The relic itself was taken away by the last Grand Master Ferdinand von Hompesch when he left the island in 1798.

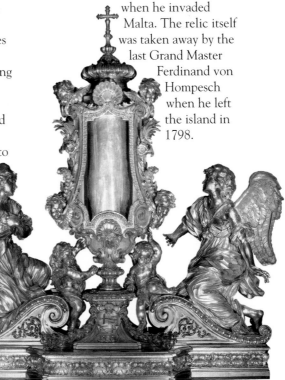

The Picture Gallery

In 1735 Grand Master Manoel de Vilhena commissioned Romano Carapecchia, the architect of the Order, to build two halls adjacent to the nave to provide room where the clergy and members of the Order could put on their ceremonial attire. The south hall today houses the picture gallery.

St John Baptizing Christ

St John Baptizing Christ by Matteo Perez d'Aleccio was the conventual church's original main altarpiece. It was replaced by the large marble group of the Baptism seen today. It belongs to the late sixteenth-century and reflects the elegant Mannerist style predominant at that time. Perez d'Aleccio was an assistant of Michelangelo Buonarroti and some of his work is to be found in the Sistine Chapel in the Vatican in Rome. He also painted the important frieze of the Great Siege at the grand master's palace in Valletta.

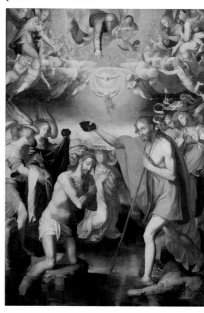

The Vestments

The various grand masters donated several sets of sacred vestments to their conventual church for used during important ceremonial occasions. The inventories of the Order record 13 such gifts. They are made out of silk, satin and profusely embroidered with multi-coloured silk yarns and gold and silver threads. The colours were chosen carefully, according to the liturgical calendar, to add symbolic meaning to the liturgy. White was the symbol of light and truth, whilst red as a symbol of sacrifice was worn on the feast of martyrs. Purple and black symbolized penance and were used during Lent. Of particular interest is the set donated by Grand Master Nicolas Cotoner. The vestments are richly embroidered with floral motifs, many of which carry a symbolic meaning. The tulip represents the bold and opulent spirit of the age, and the thistle and the violet represent penance and humility respectively.

EM. M. M. F. EMMANUELI PINTO
QUOD PRESBYTEROS CONVENT. MAGNO PALLIO COCCINEO INSIGNIRI,
ECCLESIARCHAM EPISCOPALIBUS INDUMENTIS ORNARI CURAVERIT,
EISQUE DICANTII USUM DEDERIT, POMPA IN SOLEMNITATIB.
AUCTA, ALIISQUE BENEFICIIS MUNIFICE CONLATIS .
AN. R.S. MDCCXLVII.

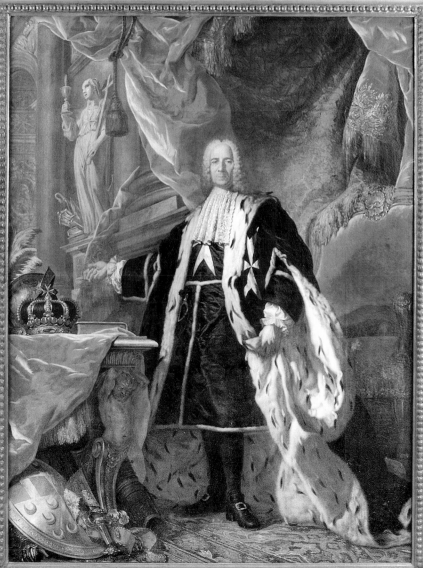

Portrait of Grand Master Emmanuel Pinto

The majestic full-length portrait of Grand Master Emmanuel Pinto de Fonseca was painted by the French artist Antoine Favray in 1747. It was commissioned by the convent in gratitude to the grand master for gaining the privilege of carrying the silver mace. The artist used a rich and grandiose treatment to depict the grand master, typical of the French style adopted by King Louis XIV of France which Pinto intentionally wanted to emulate. Standing at his desk the grand master points to his royal crown to indicate that he is the sovereign of the Order. His cape is lined with ermine, a fur worn only by royalty. His family coat of arms and his sword and armour beneath the desk are symbolic of his military role. Pinto reigned from 1741 to 1773, one of the longest periods in the history of the Order. Renowned for his flamboyant lifestyle, he rebuilt the auberge of the Castilian langue and established the university.

St George killing the Dragon by Francesco Potenzano (1540-99)

This painting once adorned the altar of the chapel of Aragon. Its gracious and elegant artistic style are typical of the Late Mannerist period. It was replaced by Preti's seventeenth-century Baroque interpretation of the same scene.

The Tryptych of the Deposition

This delicately executed work represents in the main panel the lamentation over the death of Christ. The side panels show the figures of Nicodemus and Mary Magdalene. Its restrained naturalism and keen interest in detail are characteristic of the sixteenth-century Dutch school.

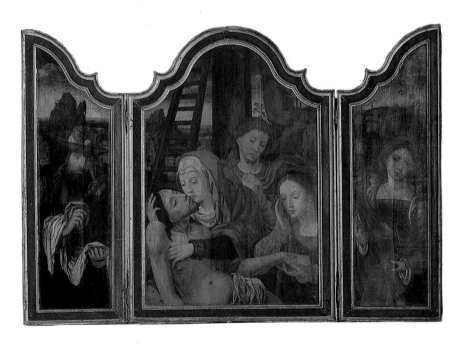